IO TID

2017 TID AWARD

2017 第十屆台灣室內設計大獎

2017 第十屆台灣室內設計大獎

CONTENTS

金獎

Gold Award

TID獎
TID Award

入圍
The List of
Primary Selected
Projects

贊助廠商 Sponsors

索引 Index

為社會創新而設計
定義亞洲觀點

兩岸三地室內設計專業人員視為獲獎榮耀的「TID Award」，已邁入第九年，在姚政仲與王玉麟兩位前任理事長的大力推動下，八年來在台灣、甚至在亞洲，已經奠定了專業的評審標準和新的美學觀點；而身為第九屆理事長，我非常期待在任內，能為「TID Award」開啟更廣闊的面向。

這些年來台灣的「TID Award」一直是世界和亞洲最具時代性、最具前瞻實驗美學的作品競賽平台之一！同時，我們更企圖從這個獎項的作品當中，能看到台灣自身的空間美學與材料構築之外；當我們將眼界朝向世界時，「TID Award」不再只是屬於台灣的一個獎項，它必須擴大屬於大亞洲華人地區—包括台灣、香港、中國大陸、新加坡、馬來西亞等—所有以華人觀點為基礎的亞洲定位。因此，我們藉由將TID Award的得獎作品，帶到「倫敦設計節」、甚至和日本、香港、深圳的城市交流，讓台灣成為面對「全球化」的一個非常重要的軸點，也讓更多來自亞洲各地傑出設計人才能以這個競逐平台，展現出華人的空間美學和生活文化。

另一方面，除了面對自己、面對亞洲、面對世界之外，我們也企圖思考如何面對時代改變與演進，讓設計可以面向社會、面向公共、面向創新！我們今年希望提醒所有設計師能「為社會創新而設計」，也就是所謂的「社會設計」（Social Design）—讓空間設計不只是以空間為本質而已，而是關於

人們如何想像、改造、落實一個更好的社會，傳遞出台灣的價值與認同的新思惟動力。進而，面對當代的時代趨勢，讓空間不只是設計者自我想像與構築的空間而已，而是一個跨域整合的傳達設計 (Communication Design)—更重視整合性的意念溝通，將媒體、品牌或活動完美地融合在空間整體之中，創造「TID Award」的作品走向更多元有機、更實驗創新的可能。

同時，我們在今年的評審結構上，也為了這個多元創新而進行了部分調整，在初、複、決選評審當中，加入了藝術文化、社會創新、生活美學等面向作為評分元素之一，多邀請了「漣漪人基金會」董事長朱平、資深媒體人及作家詹偉雄、生活美學家安郁茜等各界重量級人士擔任評審，從藝術、文化、商業、品牌各個角度切入，激盪出新的化學作用。不僅如此，我們也邀請國際知名設計大師季裕棠(Tony Chi)及紅點設計(Red Dot Design Award)主席Peter Zec，以國際華人和全球設計平台的觀點來審視作品。而在專業方面，則特別邀請在藝術文化擁有深度內涵與見解的台灣最具影響力設計師陳瑞憲和關傳雍，從專業層次到室內空間材料美學的運用，提供不同觀點，的確讓今年決選出了更多元樣貌的作品，更賦予了「TID Award」漸漸清晰的獨特視野。

我想明年第十屆的「TID Award」，我們將會回應今年的觀點和嘗試，設立一些新的空間獎項—包括永續設計 (Sustainability Design) 、社會設計 (Social Design)、創新設計獎 (Innovation Design)、以及品牌設計 (Branding & Communication)等—以回應21世紀的設計趨勢，讓設計師不只是在追求風格，而是開啟面向社會性、公共性、溝通性、更同時展現了亞洲觀點和時代精神，讓「TID Award」能創造出一個新的里程碑！

決審評審

Designing for Social Innovation-
Defining Asia's Diversity

The TID Award, architecture's prestigious award for design professionals in Taiwan and across the strait, has entered its ninth year. With great efforts from former CSID presidents, Cheng-Chung Yao and Yul-Lin Wang, the TID Award has established itself as the professional standard for evaluating design aesthetics in Asia. As the president of CSID's ninth year, I very much look forward to opening a new chapter for the TID Award in broadening its scope.

Over the years the TID Award has become one of the foremost and experimental platforms for design competitions, both in Asia and in the World! At the same time, from these awarded projects we can see beyond Taiwanese design in space aesthetics and material structures; we shall put our eye on the world, TID Award is not just an award belonging to Taiwan, it must belong to the entire Greater China Region, to include not only Taiwan, but also Hong Kong, China, Singapore, Malaysia and etc. Thus, we have brought the TID Award projects to the London Design Festival and also Japan, Hong Kong, Shenzhen and other Asian cities, as a pivot to 'globalize' Taiwan. We hope to allow more talented people to participate in this competition platform, to express Asian spatial aesthetics and lifestyles.

On the other hand, besides facing ourselves, Asia and the world, we must also endeavor to think about how to face the changing times and its evolutions. How do we allow design to face the society, public and innovation! This year we hope to remind designers to "Design for Social Innovation," i.e., make "Social Design" that treats interior design as not just a space itself, but a product of how people

think, transform and create a better society. In the face of the changing times, space is no longer just an imagined and constructed reality; it is a cross-disciplinary "Communication Design," an integrative entity that seamlessly combines space with the media, branding and activities. The TID Award shall march toward a more diversified, more experimental and more innovative future.

At the same time, we have made adjustments on the organization of the jury. For the preliminary, intermediary and final jury, we added arts & culture, social innovation and living aesthetics and etc. as criteria for critiquing. We also invited Chairman of Ripplemaker Foundation Pin Chu, literary scholar Wei-Hsiung Chan and lifestyle guru Yu-Chien Ann, as a way of introducing art, culture, commerce and branding into the jury perspectives and as catalysts for new chemistry. Additionally, we have invited world renowned designer Tony Chi and Chairman of Red Dot Design Award Peter Zec, who offer us global view on design. For design professionals, we invited Ray Chen and Ernest Guan, who are extremely knowledgeable and influential in the industry, and provide deep insights on culture and aesthetics. From professionalism to interior design materials and methods, our team of jurors delivered perspectives from different backgrounds and greatly diversified this year's project selections. We can see that the unique outlook provided by the TID Award has gradually become clearer.

I think for next year's 10th Annual TID Award, we will add some new award categories to respond to new design trends of the 21st century, categories such as Sustainability Design, Social Design, Innovation Design, Branding & Communication and etc. More than just a pursuit for signature style, we want to let designers become more open to social, public, communicative, Asian infused and timeless designs. Let us open a new chapter for the TID Award!

複審評審

JURY

INTRODUCTION

評 審 介 紹

FINAL JUROR
決審評審

決審評審
Final Juror

Tony Chi
季裕棠
Tony Chi & Associates

決審評審
Final Juror

Peter Zec
紅點創辦人兼執行長
CEO of the red dot Award, Germany

決審評審
Final Juror

Wong Mun Summ
Founding Director of WOHA

FINAL JUROR
決審評審

決審評審
Final Juror

龔書章
Kung, Shu-Chang

中華民國室內設計協會理事長
President of Chinese Society of Interior Designers
(CSID)
國立交通大學建築研究所 任教授
Professor, Gratuate Institute of Architecture,
National Chiao Tung University (NCTU), Taiwan

決審評審
Final Juror

關傳雍
ERNEST GUAN

關傳雍設計工作室-主持設計師
Guan and Hu Desgin Studio

決審評審
Final Juror

張光民
Tony K.M. Chang

國際工業設計團體聯盟 國際理事
Executive Board Director of the
International Council of Societies of Industrial Design
(ICSID)

決審評審
Final Juror

陳瑞憲
Ray Chen

三石建築師事務所
Ray Chen and Partners Architects

決審評審
Final Juror

黃湘娟
Peggy Huang

《室內》雜誌總編輯
Editor-in-chief of Interior Magazine

決審評審
Final Juror

安郁茜
Ann Yu-Chien

SEMI-FINAL JUROR 複審評審

複審評審
Semi-final Juror
王玉麟
Yul-Lin Wang
中華民國室內設計協會 榮譽理事長
Honorary President of Chinese Society of
Interior Designers (CSID)

複審評審
Semi-final Juror
楊岸
Alexander Yang
今品空間計畫有限公司設計總監

複審評審
Semi-final Juror
杜祖業
Tsu-Ye Du
GQ國際中文版 總編輯
Editor-in-Chief, GQ Magazine Taiwan

複審評審
Semi-final Juror

胡碩峯
Shyr-Fong Hu

胡碩峰建築工作室 設計總監
Director Of Shyr-Fong Hu
Design Studio

複審評審
Semi-final Juror

胡德如
Te-Ju Hu

藝術美學專家
Art aesthetics specialist

複審評審
Semi-final Juror

林平 **Ping Lin**

臺北市立美術館 館長
Director of Taipei Fine Arts Museum

GOLD

AWARD

TID
金獎

工作空間類 金獎　大象群文化傳媒辦公設計

THE TID GOLD AWARD OF
WORKING SPACE

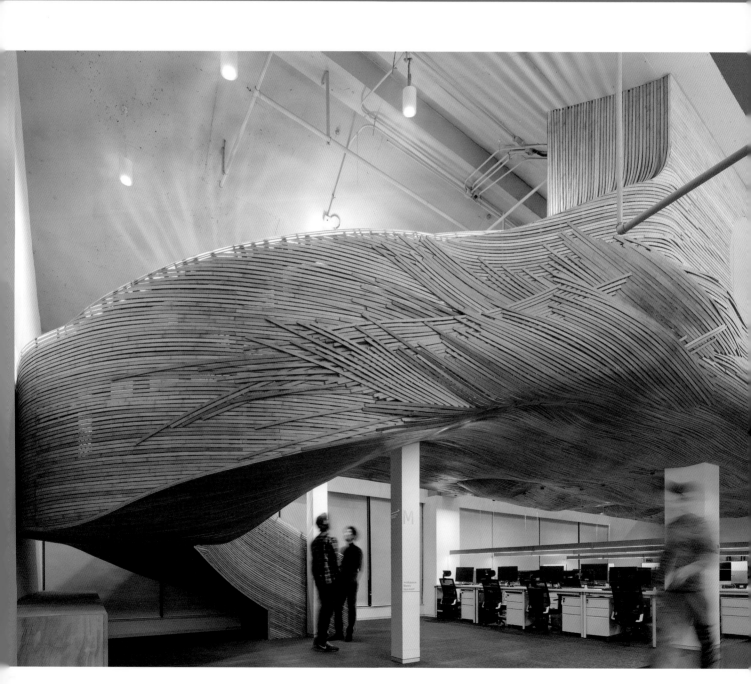

大象群文化傳媒辦公設計
中國／北京
業主／世紀大象群文化傳播
　　　（北京）有限公司
設計者／崔樹
設計公司／CUN寸DESIGN
作品攝影者／王廳、王瑾

Space Design of Elephant-Parade Office

China / Beijing
Client / Beijing Elephant-Parade Culture &
　　　Communications Co. Ltd.
Designer / Cui Shu
Company / CUN-DESIGN
Photographer / Wang Ting, Wang Jin

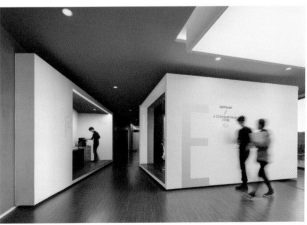

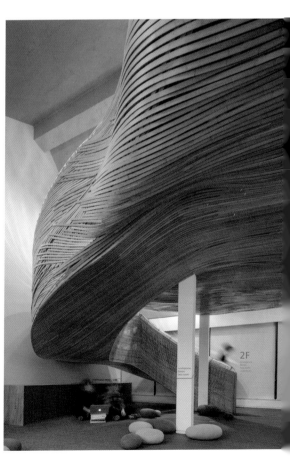

The 10th Taiwan Interior Design Award　16 | 17

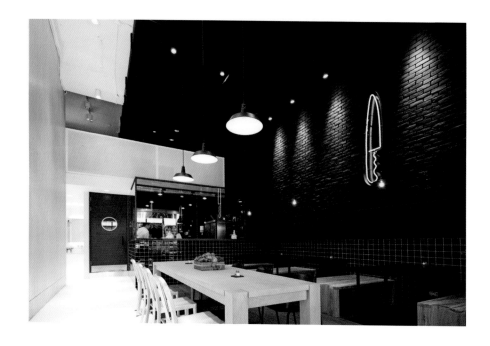

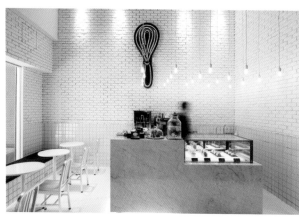

RL

台灣／桃園市
業主／雋瑞有限公司
設計者／林旻漢
設計公司／合聿設計工作室
作品攝影者／巫瑋哲

RL

Taiwan / Taoyuan City
Client / Chun Rui Co., Ltd.
Designer / Min Han Lin
Company / Union Atelier
Photographer / Wei Che Wu

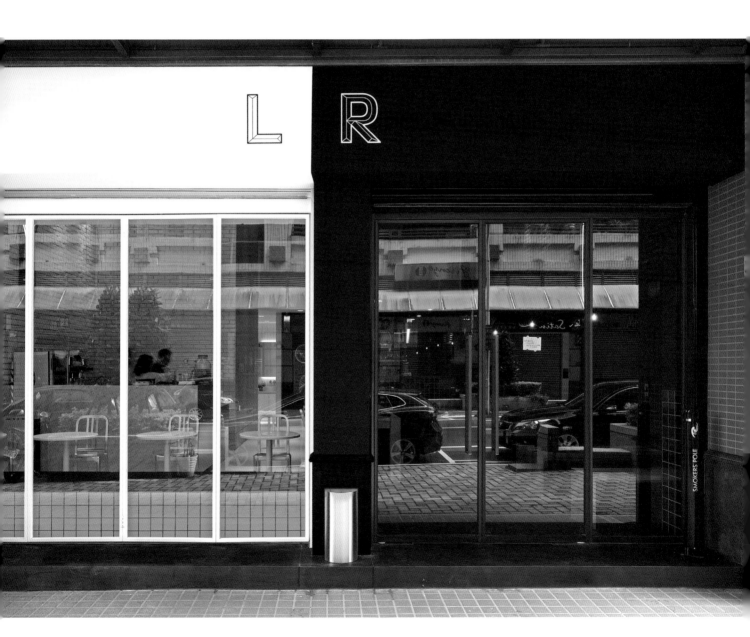

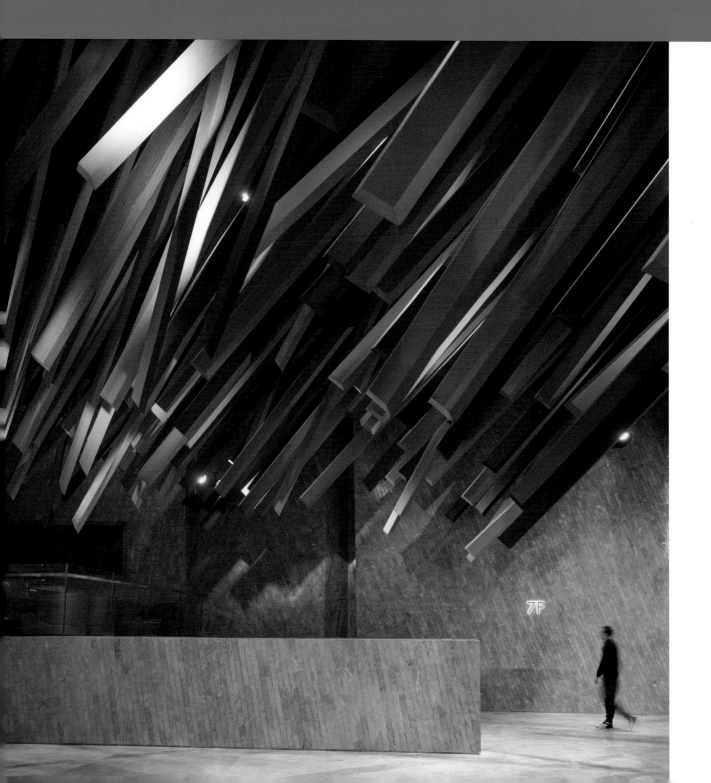

商業空間類／休閒空間 金獎　金逸影城（廣州海珠城IMAX店）

THE TID GOLD AWARD OF
COMMERCIAL SPACE　HOSPITALITY SPACE

金逸影城
（廣州海珠城IMAX店）

中國／廣州
業主／廣州金逸影視傳媒
　　　股份有限公司
設計者／羅靈傑、龍慧祺
設計公司／壹正企劃有限公司
作品攝影者／雷壇壇

Guangzhou Jinyi Cinemas

China / Guangzhou
Client / Guangzhou Jinyi Film &
Television Media Co.,Ltd
Designer / Ajax Law, Virginia Lung
Company / One Plus Partnership Limited
Photographer / Jonathan Leijonhufvud

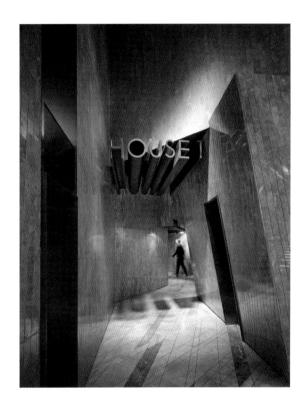

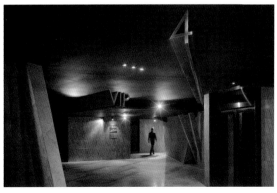

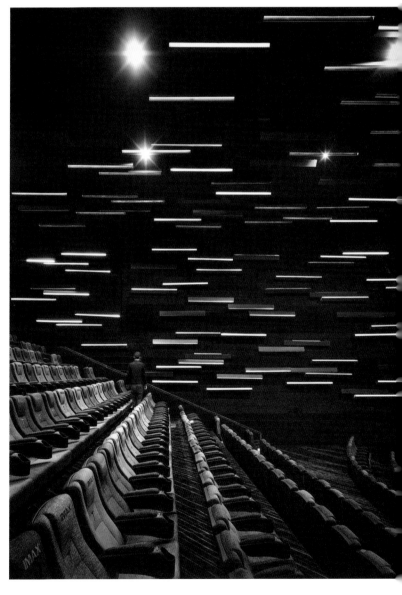

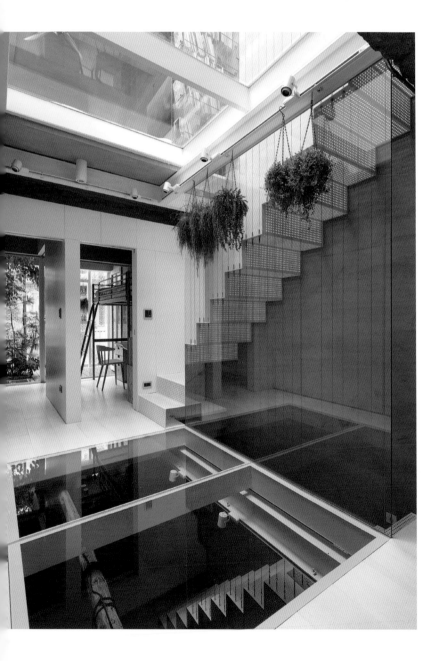

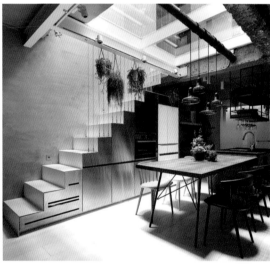

士林王宅

台灣／台北市
設計者／劉冠漢、曹均達
設計公司／均漢設計有限公司
作品攝影者／岑修賢

House W

Taiwan / Taipei City
Designer / Kuan-huan Liu, Chun-ta Tsao
Company / KC Design Studio
Photographer / Siew Shien Sam

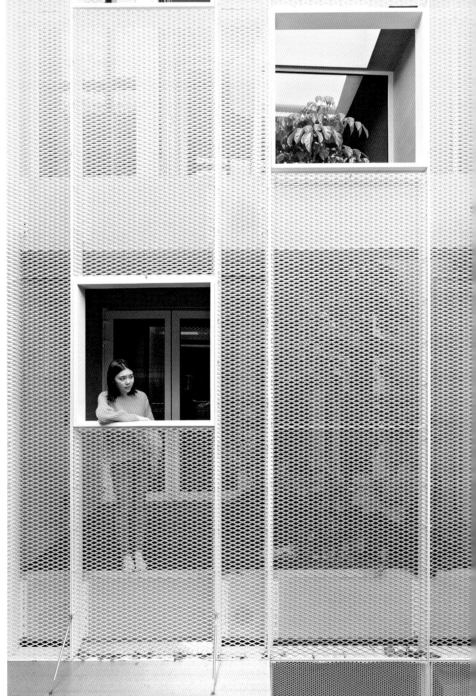

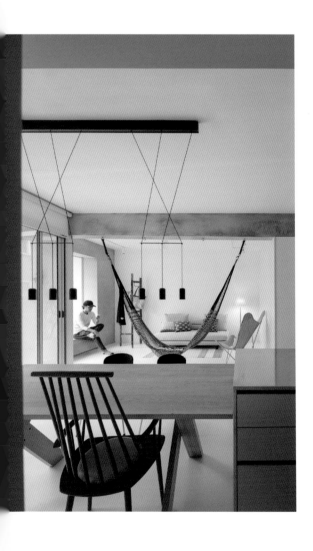

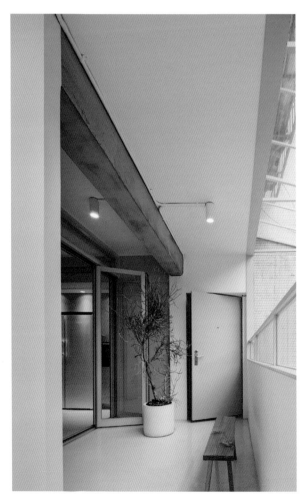

張宅
台灣／台北市
業主／張先生
設計者／翁梓富
設計公司／兩冊空間設計
作品攝影者／亮點影像

C HOUSE
Taiwan / Taipei City
Client / Mr. Chang
Designer / Jeff Weng
Company / 2BOOKS DESIGN
Photographer / Highlite Image

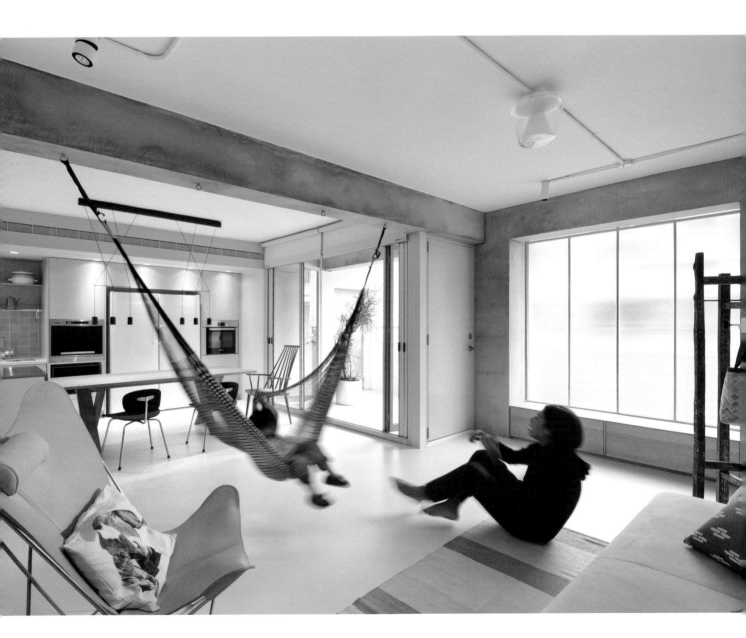

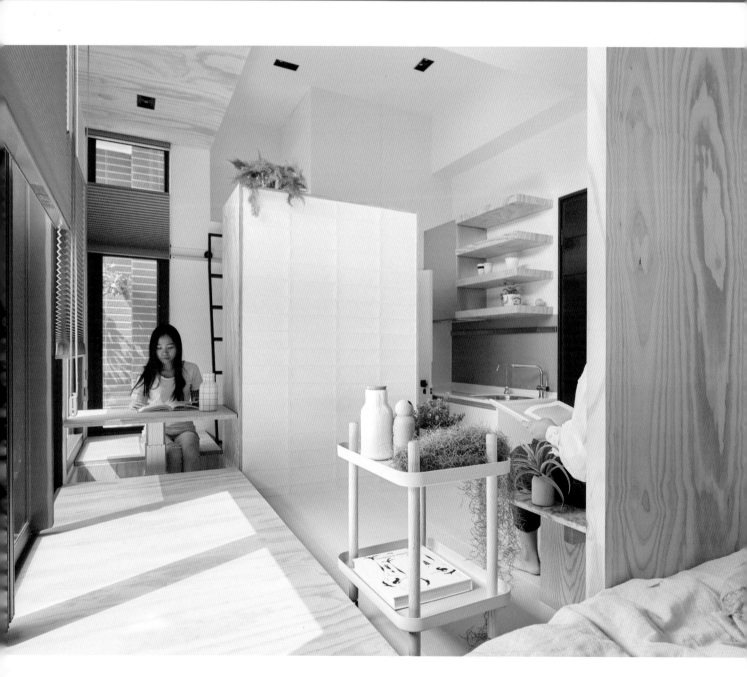

Multi-function with Balance

台灣／台北市
業主／顏明德、王慧群
設計者／黃鈴芳
設計公司／馥閣設計整合有限公司
作品攝影者／嘿！起司

Multi-function with Balance

Taiwan / Taipei City
Client / Ming-De Yan, Hui-Chun Wang
Company / Fuge Design Integration
 Co., Ltd.
Designer / Ling-Fang Huang
Photographer / Hey! Cheese

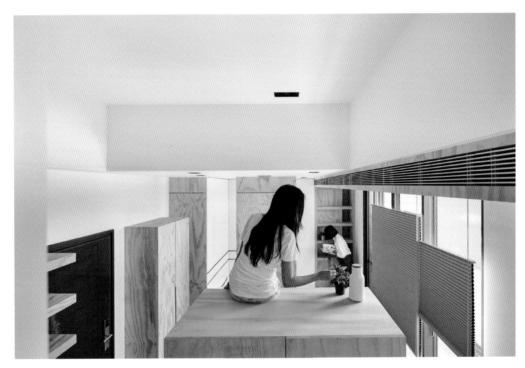
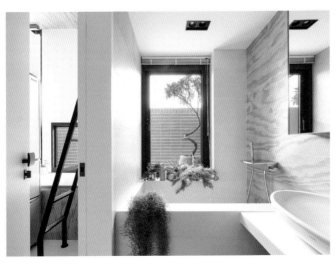
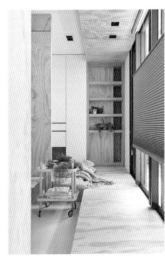

展覽空間類 金獎 · 新銳獎 　時代·柏林

THE TID GOLD AWARD OF
EXHIBITIONS SPACE/ **TIDING AWARD**

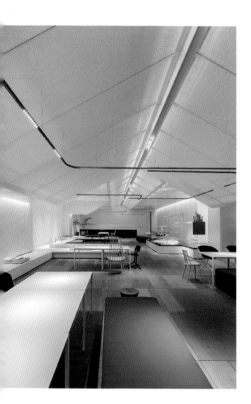

時代・柏林

中國／廣州市
設計者／余霖
設計公司／東倉裝飾設計有限公司

Time Berlin

China / Guangzhou City
Designer / Ann Yu
Company / DOMANI Architectural
Concepts

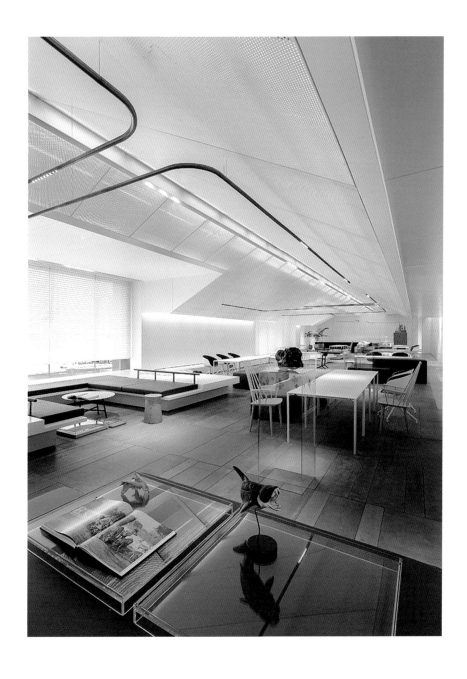

THE TID GOLD AWARD OF
INTERIM ARCHITECTURE & INSTALLATION

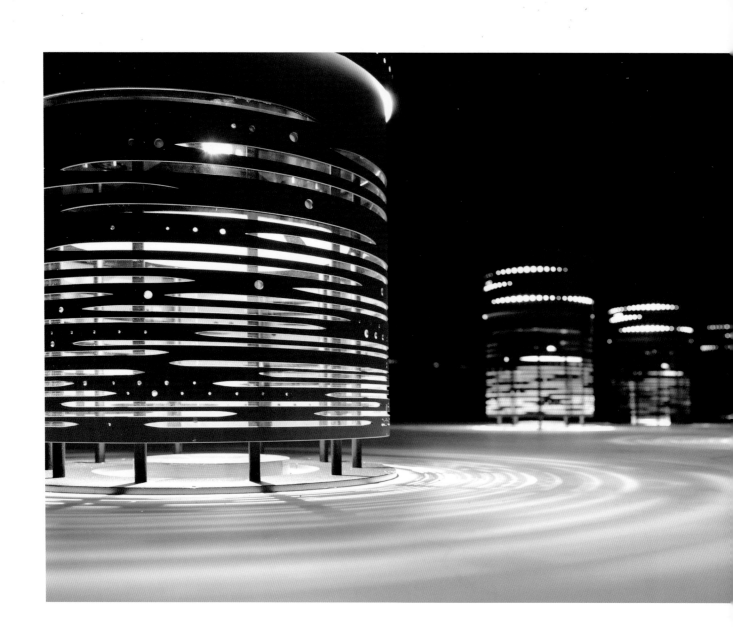

力光見影

台灣／南投縣
業主／宜東文化創意有限公司
設計者／林靖祐
設計公司／沁弦國際設計有限公司
作品攝影者／陳藝堂、劉森湧

Pressure Effects

Taiwan / Nantou County
Client / Art Happening Ltd.
Designer / Ching-Yu Lin
Company / CosmoC design, Ltd.
Photographer / Chen Etang
 Liu Sen-yung

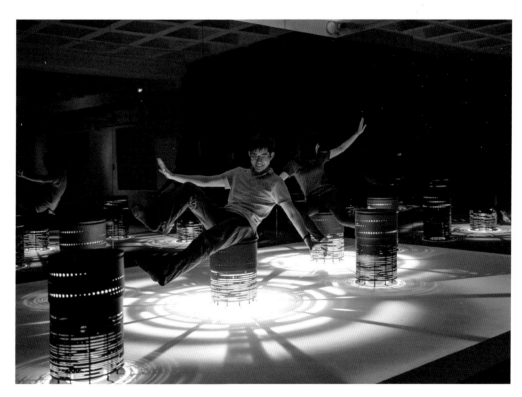

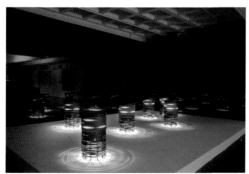

品牌設計類 金獎　沃坦匠藝 台北展示店

THE TID GOLD AWARD OF
BRANDING & COMMUNICATION

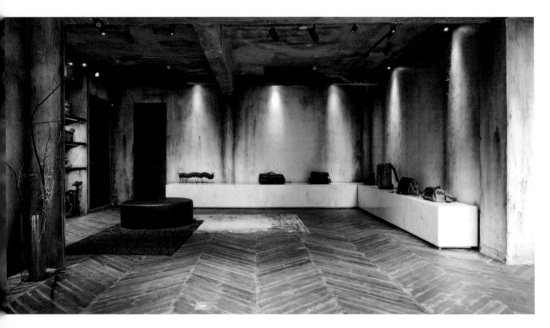

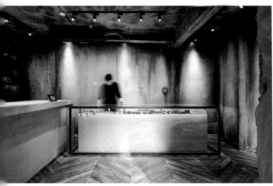

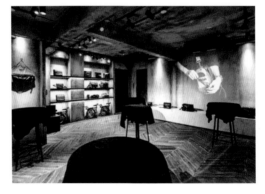

沃坦匠藝 台北展示店

台灣／台北市
業主／沃坦匠藝
設計者／袁丕宇、王正行、張豐祥
設計公司／工一設計有限公司
作品攝影者／岑修賢

Wotancraft Brand-Store

Taiwan / Taipei City
Client / Wotancraft
Designer / Pi-Yu Yuan, Cheng-Shing Wang
 Feng-Hsiang Chang
Company / One Work Design
Photographer / Sam

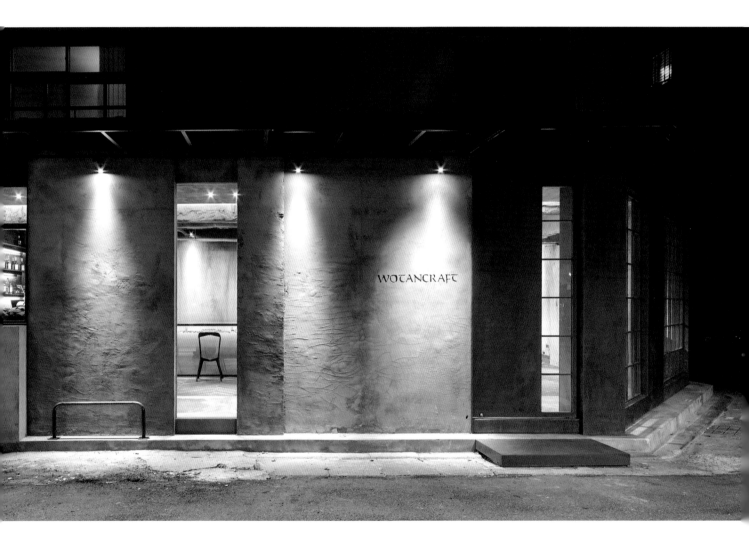

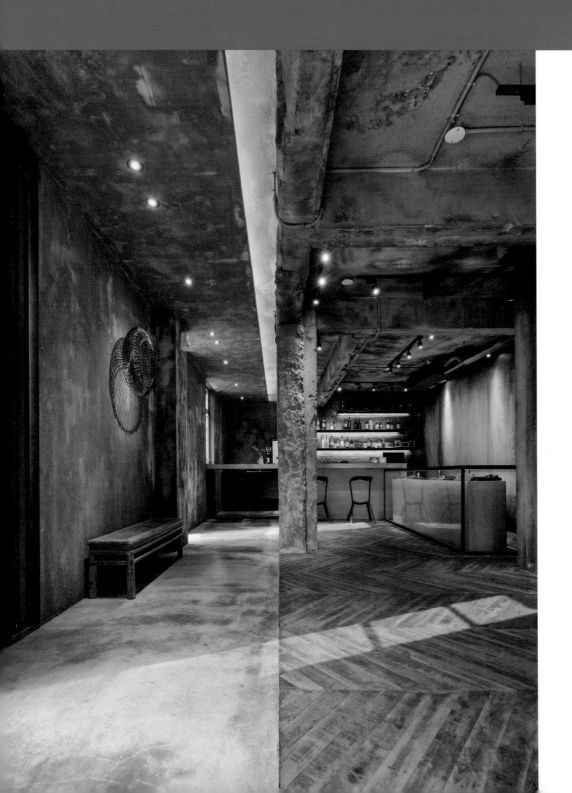

W空間

台灣／台北市
業主／沃坦匠藝
設計者／袁丕宇、王正行、張豐祥
設計公司／工一設計有限公司
作品攝影者／岑修賢

The W space

Taiwan / Taipei City
Client / Wotancraft
Designer / Pi-Yu Yuan, Cheng-Shing Wang
　　　　　　Feng-Hsiang Chang
Company / One Work Design
Photographer / Sam

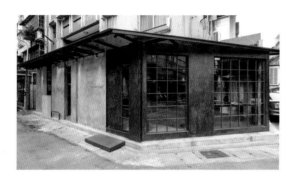

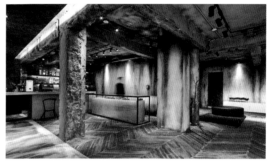

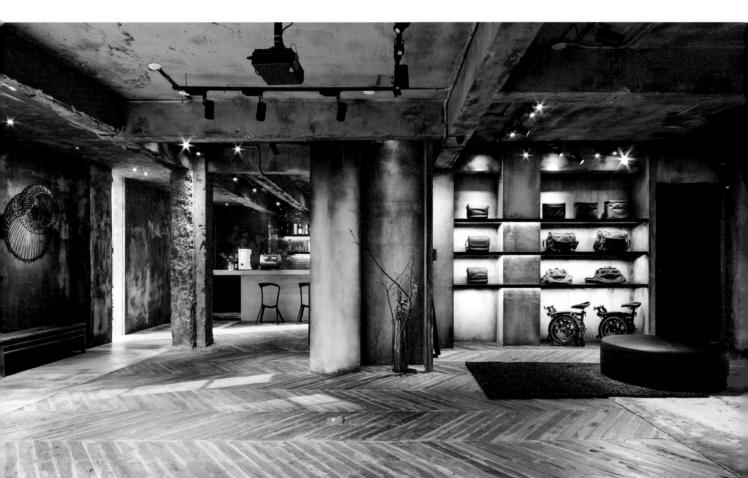

2017評審特別獎

盒裡盒外：APF KAFE

2017
SPECIAL
JURY AWARD

盒裡盒外：APF KAFE

中國／廣州市
設計者／陸穎芝
設計公司／芝作室
作品攝影者／Dirk Weiblen

In and between boxes: APF KAFE

China / Guangzhou City
Designer / Christina Luk
Company / Lukstudio
Photographer / Dirk Weiblen

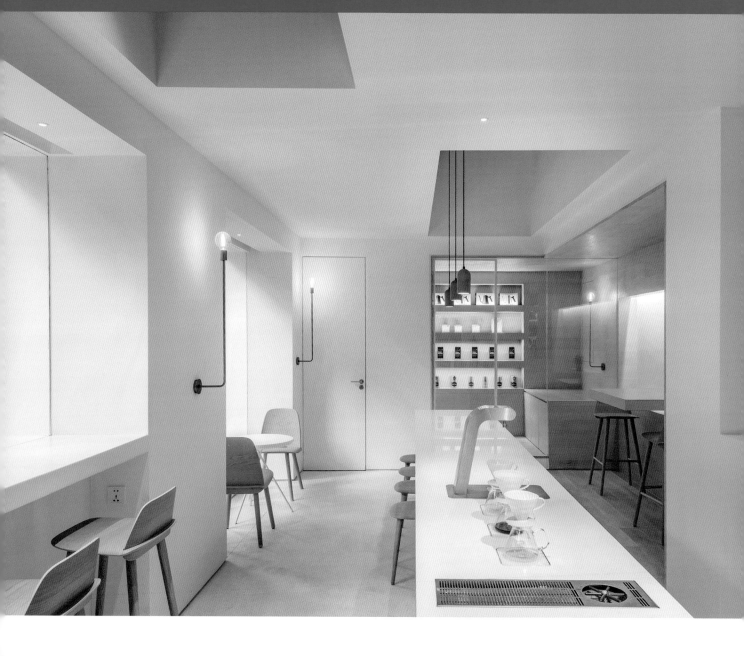

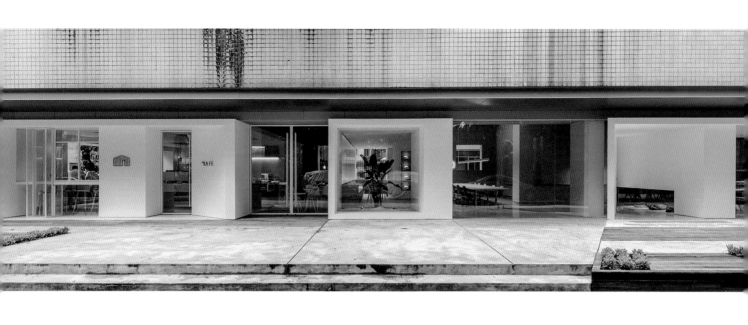

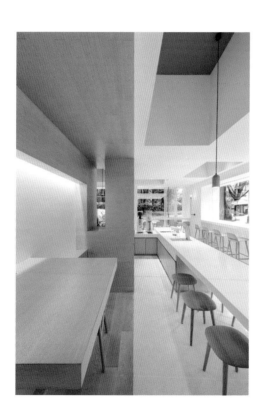

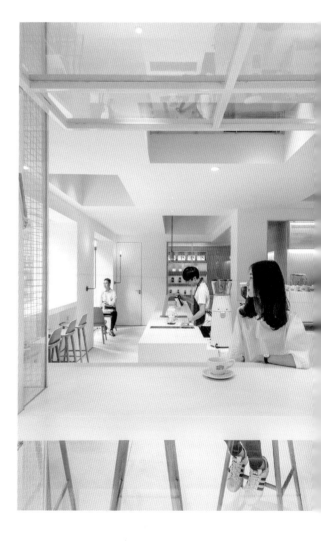

2017評審特別獎

簡 舍

2017
SPECIAL
JURY AWARD

簡舍
台灣／桃園市
業主／簡張玉春、簡茂椿
設計者／簡祺珅
設計公司／深宇建築師事務所
作品攝影者／簡祺珅

Chien House

Taiwan / Taoyuan City
Client / Yu-chun Chien Chang, Mao-chuang Chien
Designer / Chi-shen Chien
Company / Architect Uncharted
Photographer / Chi-shen Chien

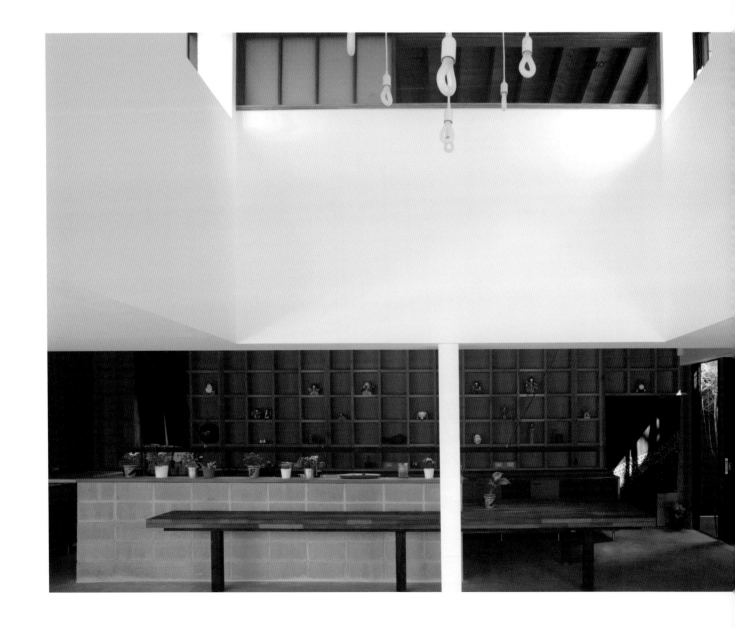

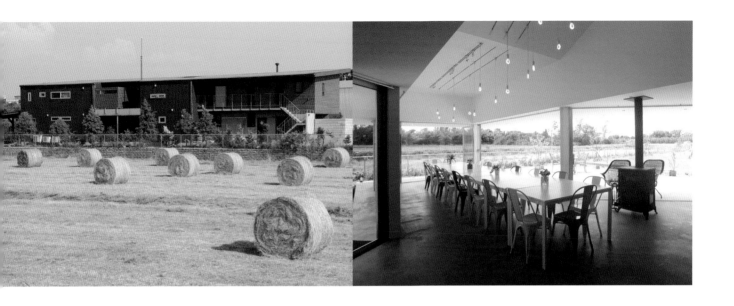

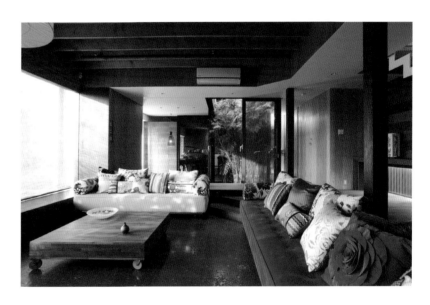

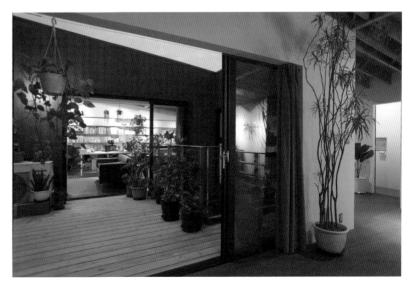

ParkUp

台灣／台北市
業主／第二計劃
設計者／游適任、張憲文、林家琪
設計公司／第二計劃
作品攝影者／林家琪

ParkUp

Taiwan / Taipei City
Client / Plan b
Designer / Justin Yu, Hsien-Wen Chang, Chia-Chi Lin
Company / Plan b
Photographer / Chia-Chi Lin

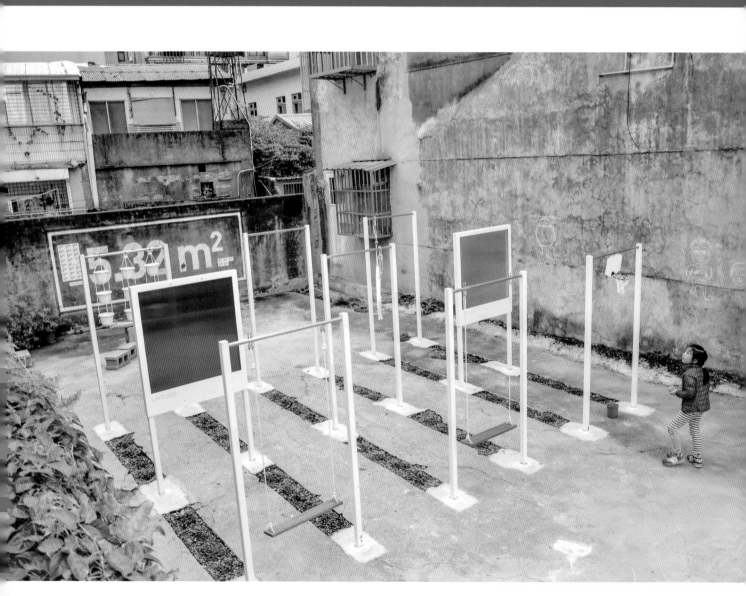

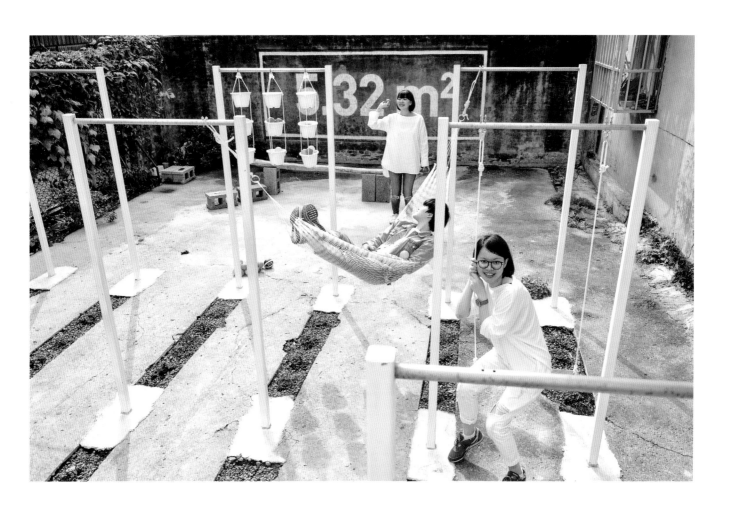

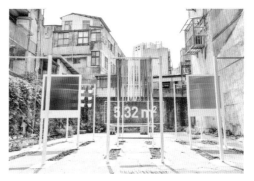

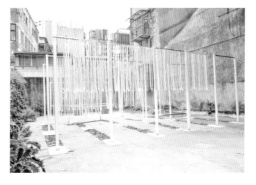

TID

AWARD

TID獎

探索知徑-蘇州誠品

中國／蘇州

業主／誠品股份有限公司

設計者／鄧運鴻、胡肖玫

設計公司／元崇設計工程
股份有限公司

作品攝影者／盧春宇

**An Exploration Stage -
Eslite Spectrum, Suzhou**

China / Suzhou

Client / The Eslite Corporation

Designer / Chris Y. Teng, Portia Hu

Company / Mandartech Interiors Inc

Photographer / Clive Lu

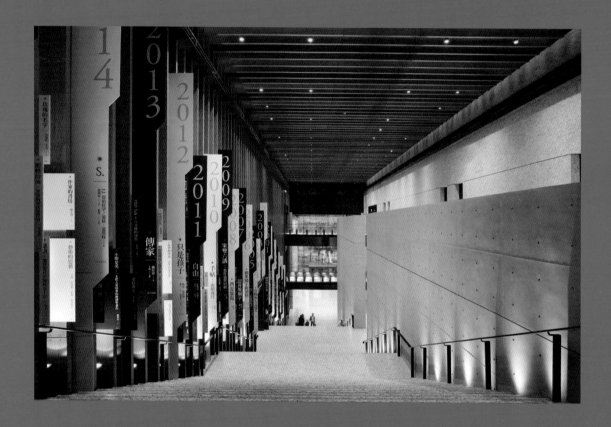

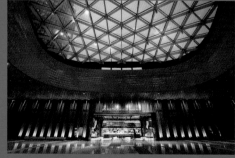

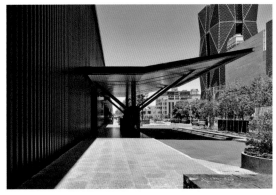
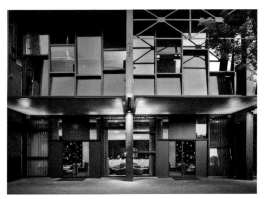
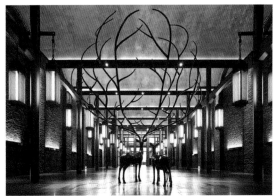
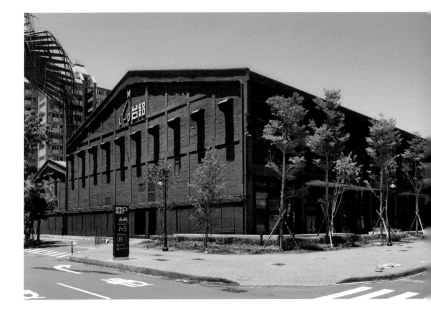

MLD台鋁

台灣／高雄市
業主／都會生活開發股份有限公司
設計者／郭耀煌、郭璧瑩、韓桂平、魏誌皇
設計公司／宇寬設計事業有限公司
作品攝影者／李國民影像事務所

MLD

Taiwan / Kaohsiung City
Client / MLD Ltd.
Designer / Yao-Huang Kuo, Joyce Kuo, Kooi-Peng
Han, Lawrence Wei
Company / Koan Design
Photographer / Figure x Lee kuo-min Studio

自然的感知_中央研究院生態時代館

台灣／台北市
業主／中央研究院
設計者／楊秋煜、張雯怡、劉彥佑
設計公司／上滕聯合建築師事務所
作品攝影者／游宏祥

Perception of Nature_
SINICA Eco Pavilion

Taiwan / Taipei City
Client / ACADEMIA SINICA
Designer / Sam Yang, Ally Chang, UZ Liu
Company / Emerge Architects & Associates
Photographer / Kyle Yu

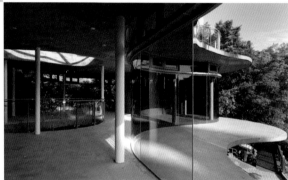

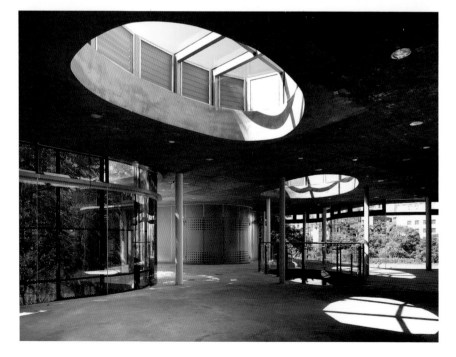

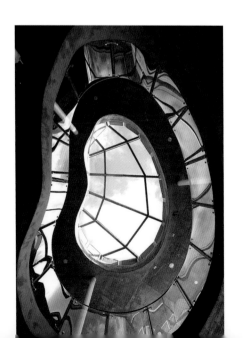

LUNA SALON-粹

台灣／彰化市
設計者／張育睿
設計公司／合風蒼飛設計工作室
作品攝影者／游宏祥

LUNA SALON- The Essence

Taiwan / Changhua City
Designer / Yu-Jui Chang
Company / Soar Design Studio
Photographer / Kyle Yu

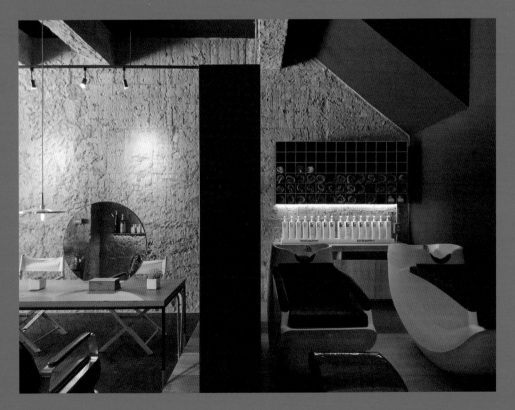

入境

台灣／台北市
業主／仁愛傑生牙科
設計者／唐忠漢
設計公司／近境制作設計有限公司
作品攝影者／岑修賢攝影工作室

The Midst

Taiwan / Taipei City
Client / Ortho Jason dental clinic
Designer / Chung-han Tang
Company / Design Apartment
Photographer / MW Photo Inc.

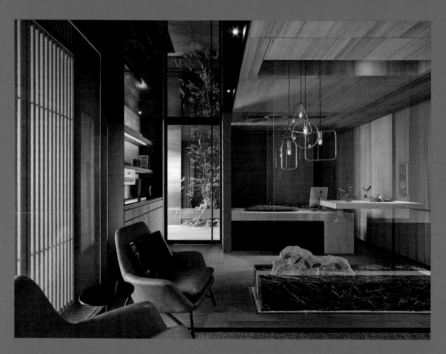

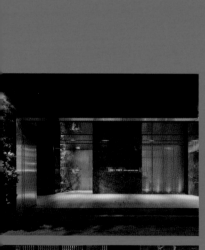

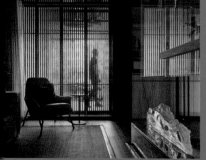

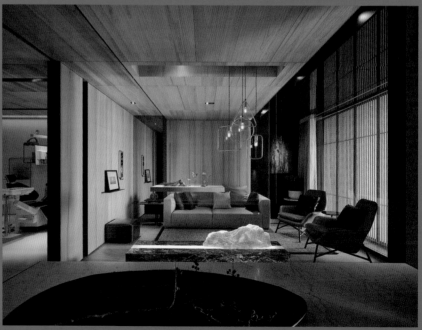

福茂大勤辦公室

台灣／新北市
業主／福茂大勤股份有限公司
設計者／邱柏文、王菱橚
設計公司／柏成設計有限公司
作品攝影者／小雄梁彥影像有限公司

The loop

Taiwan / New Taipei City
Client / Foremost eMage Corporation
Designer / Johnny Chiu, Nora Wang
Company / J.C. Architecture
Photographer / Shao Shong Liang Yan
　　　　　　Photography Co., Ltd

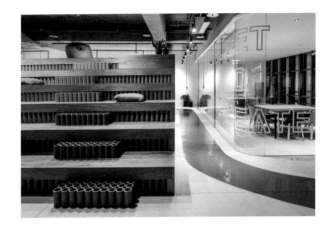

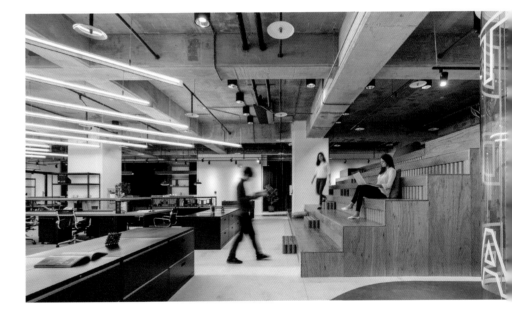

工作空間類 TID獎　層層生活研發創意空間

THE TID AWARD OF **WORKING SPACE**

層層生活研發創意空間
台灣／台北市
業主／層層生活有限公司
設計者／顏邑丞、蔡宗賢
設計公司／層層生活有限公司
作品攝影者／Krystal Lin Photography

PUL Creative Lab
Taiwan / Taipei City
Client / PileUp Life Co Ltd
Designer / Yi-Cheng Lawrence Yen
　　　　　Chung-Hsien Sam Tsai
Company / PileUp Life Co Ltd
Photographer / Krystal Lin Photography

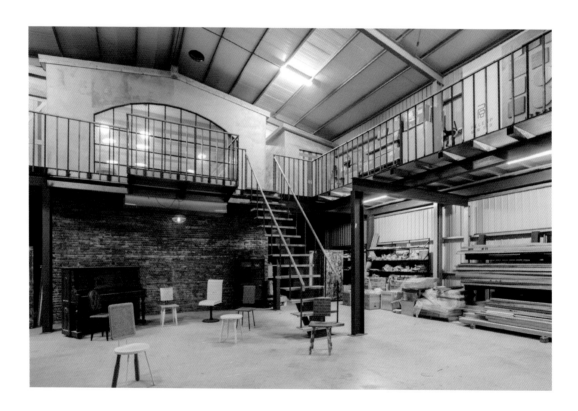

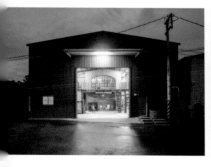
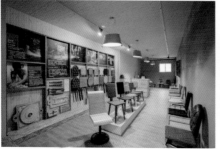
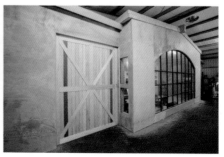

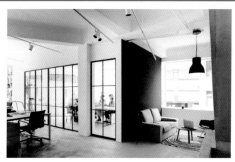

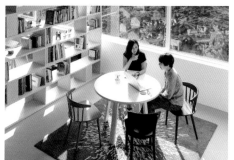

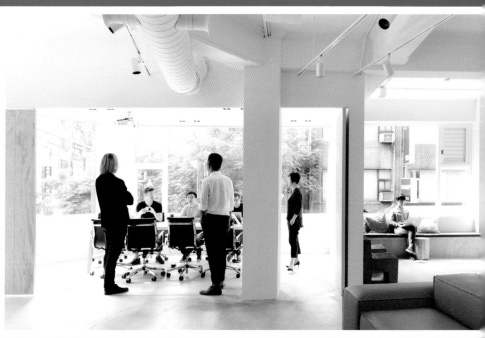

美商方策辦公室

台灣／台北市
業主／美商方策品牌顧問公司
設計者／謝佩娟、蔡智勇
設計公司／源原設計團隊
作品攝影者／Hey! Cheese

DDG Office

Taiwan / Taipei City
Client / Direction Design Group
Designer / Peny Hsieh, Calvin Tsai
Company / YYDG
Photographer / Hey! Cheese

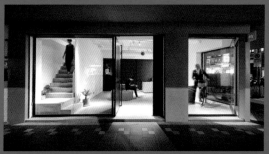

葉晋發商號：米糧桁
台灣／台北市
業主／葉晋發商號
設計者／蔡嘉豪、魏子鈞
設計公司／本埠設計 X
　　　　　兜空間設計
作品攝影者／Hey! Cheese

The Inverted Truss
-Renovation of a Historical Building

Taiwan / Taipei City
Client / Yehjinfa
Designer / Chia-Hao Tasi, Tze-Chun Wei
Company / B+P Architects x Dotze
　　　　　Innovations Studio
Photographer / Hey! Cheese

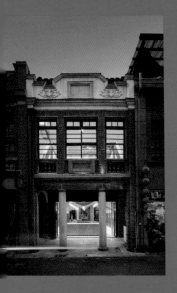
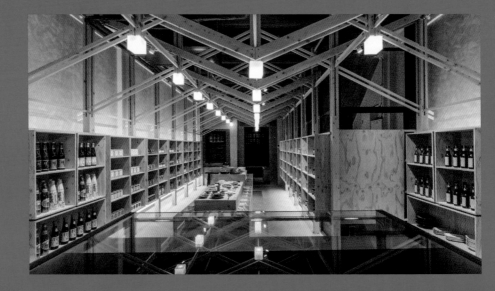
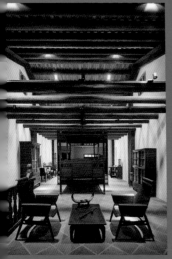
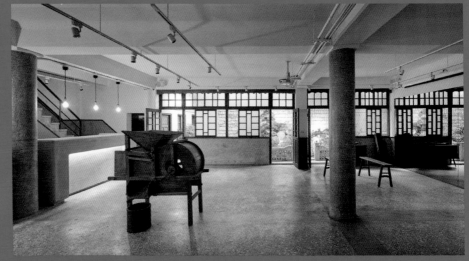

商業空間類/購物空間 TID獎 逆向

THE TID AWARD OF **COMMERCIAL SPACE**

SHOPPING SPACE

逆向

台灣／台北市
業主／謝先生
設計者／李中霖
設計公司／雲邑室內設計
作品攝影者／海瑞揚

Reversal

Taiwan / Taipei City
Client / Mr.Xie
Designer / Chung-Lin,Lee
Company / Yun-Yih Interior Design
Photographer / Dirk Heindoerfer

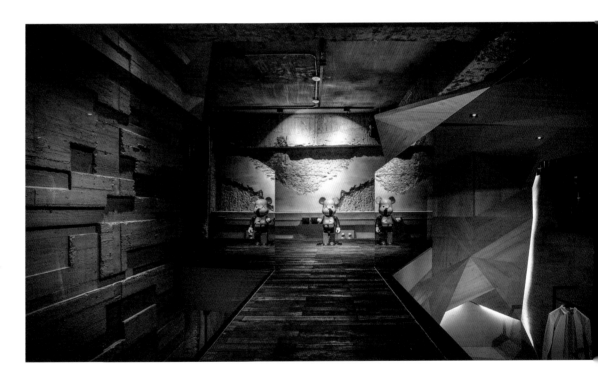

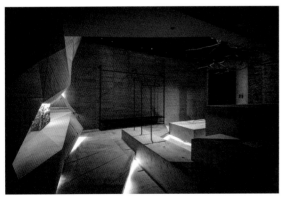

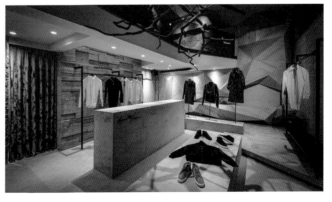

商業空間類/購物空間 **TID**獎 　UR 藝術空間

THE TID AWARD OF **COMMERCIAL SPACE**

SHOPPING SPACE

UR 藝術空間

中國／四川
業主／URBAN REVIVO, UR
設計者／余霖
設計公司／廣州市東倉裝飾
　　　　設計有限公司

Urben Revivo Art

China / Si Chuan Province
Client / URBAN REVIVO, UR
Designer / Ann Yu
Company / DOMANI Architectural Concepts

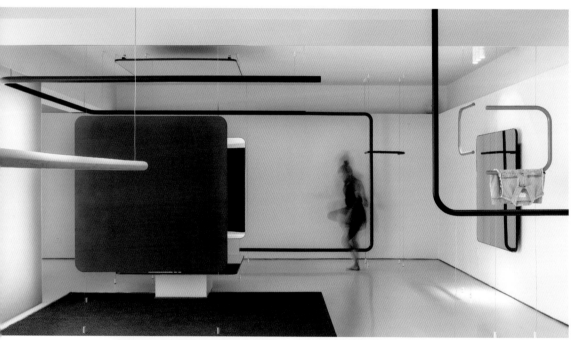

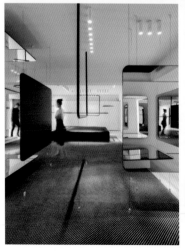

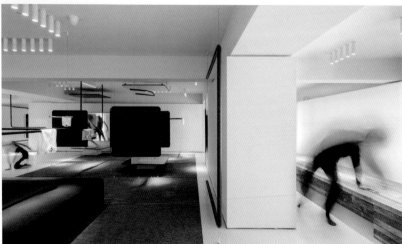

THE TID AWARD OF **COMMERCIAL SPACE**
FOOD & BEVERAGE SPACE

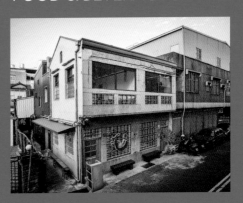

老屋猶新。毛房蔥柚鍋

台灣／台南市
業主／豐舟國際股份有限公司
設計者／黃家祥、陳宣維
設計公司／木介空間設計有限公司
作品攝影者／無著色空間影像

The rebirth of an old house-Mao Fun

Taiwan / Tainan City
Client / RICH BOAT International Co., Ltd
Designer / Chia-Hsiang Huang, Hsuan-Wei Chen
Company / MUJIE Design Co.,Ltd
Photographer / Uncoloredspace

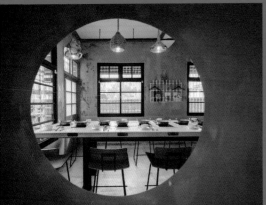

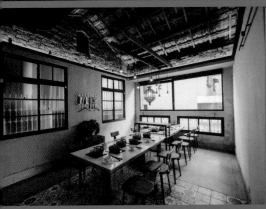

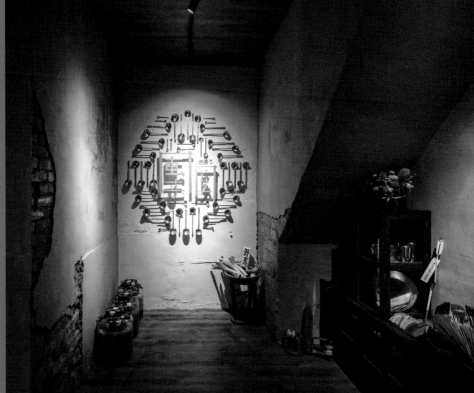

木門咖啡
台灣／台中市
業主／木門咖啡
設計者／陳惠玲
設計公司／大拓設計有限公司
作品攝影者／劉俊傑

Wooden Door Cafe

Taiwan / Taichung City
Client / Wooden Door Cafe
Designer / Hui-Ling Chen
Company / D.T. Design
Photographer / Chun-Chieh Liu

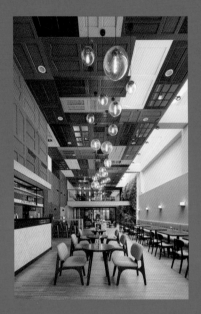

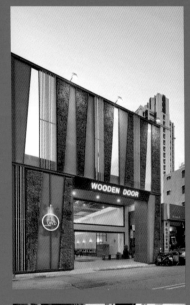

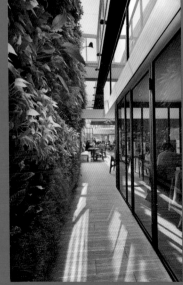

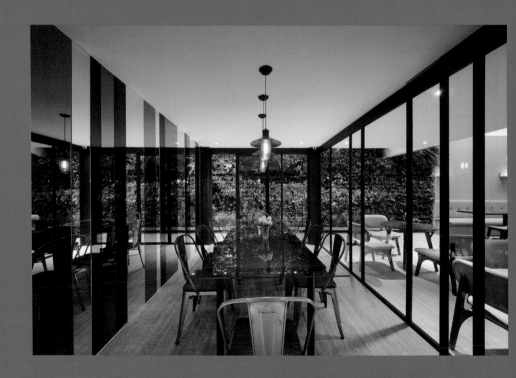

商業空間類/餐飲空間 TID獎 屋漏痕

THE TID AWARD OF COMMERCIAL SPACE

FOOD & BEVERAGE SPACE

屋漏痕

中國／深圳
業主／深圳市紫苑文化發展有限公司
設計者／馮羽
設計公司／深圳市大羽營造空間設計
　　　　　有限公司
作品攝影者／馬琪

Marks of Vernacular Architecture

China / Shenzhen
Client / Shenzhen ZiYuan Culture
　　　　Development Co., Ltd.
Designer / Yu Feng
Company / Deve Build
Photographer / Maggie Ma

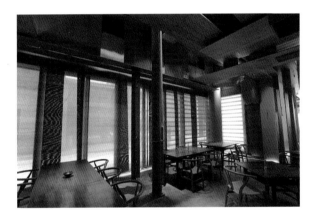

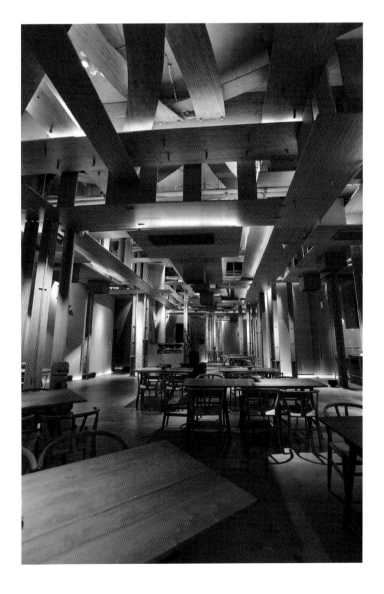

商業空間類/餐飲空間 TID獎　竹裡館

THE TID AWARD OF **COMMERCIAL SPACE**
FOOD & BEVERAGE SPACE

竹裡館

中國／南京
設計者／潘冉
設計公司／名谷設計機構

Bamboo's Eatery

China / Nanjing
Designer / Jaco Pan
Company / Minggu Design

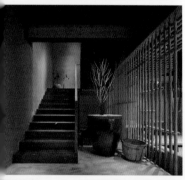

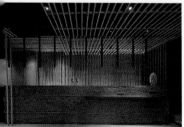

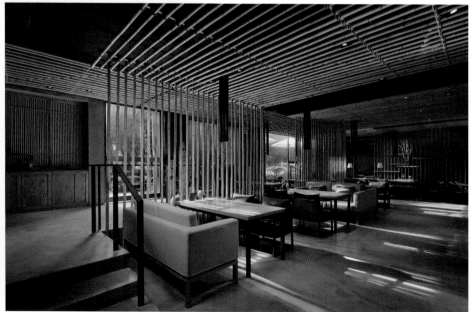

商業空間類/餐飲空間 TID獎　#OMG

THE TID AWARD OF **COMMERCIAL SPACE**

FOOD & BEVERAGE SPACE

#OMG

中國／香港
業主／美心集團
設計者／羅靈傑、龍慧祺
設計公司／壹正企劃有限公司
作品攝影者／羅靈傑、龍慧祺

#OMG

China / Hong Kong
Client / Maxim's Caterers Ltd.
Designer / Ajax Law, Virginia Lung
Company / One Plus Partnership Limited
Photographer / Ajax Law, Virginia Lung

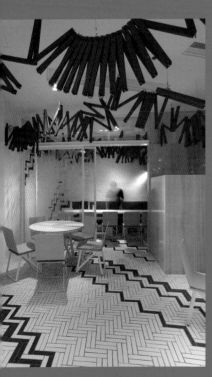

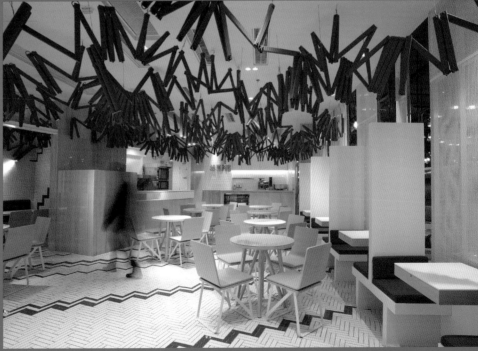

商業空間類/餐飲空間 TID獎　日式時尚-風格的原點

THE TID AWARD OF COMMERCIAL SPACE
FOOD & BEVERAGE SPACE

日式時尚-風格的原點

台灣／台北市
業主／海壽司
設計者／楊竣淞、羅尤呈
設計公司／開物設計
(開適室內裝修設計有限公司)
作品攝影者／李國民

Japanese-style Fashion.
The Origins of Style

Taiwan / Taipei City
Client / Hi Sushi
Designer / Chun-Sung Yang, Yu-Cheng Lo
Company / Ahead Concept
Photographer / Kuo-Min Lee

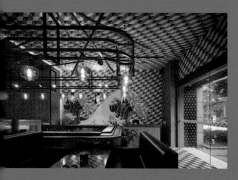

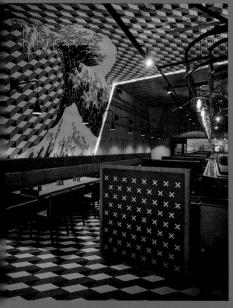

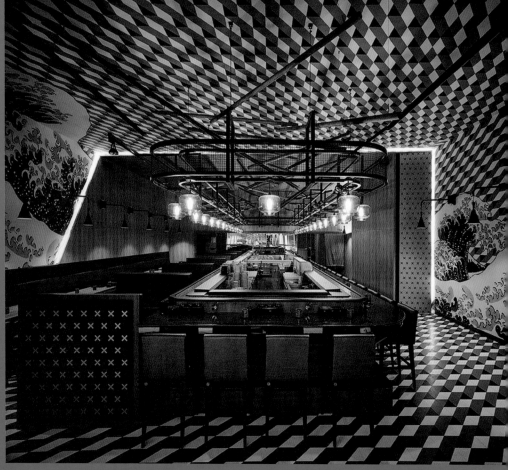

商業空間類/休閒空間 TID獎 富邦藝旅

THE TID AWARD OF **COMMERCIAL SPACE**

HOSPITALITY SPACE

富邦藝旅

台灣／台北市
業主／富邦旅館管理顧問股份有限公司
設計者／黃惠美、郭旭原
設計公司／大尺建築+郭旭原建築師事務所
作品攝影者／鄭錦銘、吳啟明、林煜煒

Folio Hotel Daan Taipei

Taiwan / Taipei City
Client / Folio Hotel
Designer / Hui-Mei Huang, Hsu-Yuan Kuo
Company / EHS ArchiLAB + Hsuyuan Kuo
Architects & Associates
Photographer / Chin-Ming Cheng, Chi-Ming
Wu, Yu-Wei Lin

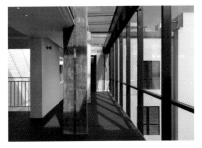

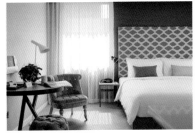

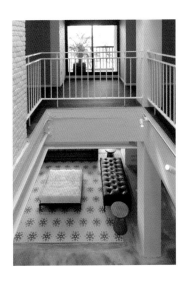

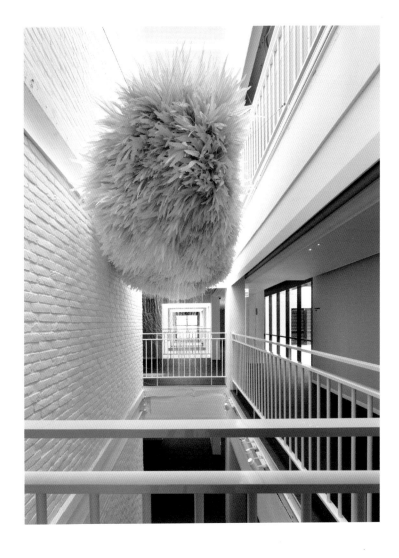

南京銀興菲林影城（老門東店）

中國／南京
設計者／羅靈傑、龍慧祺
設計公司／壹正企劃有限公司
作品攝影者／雷壇壇

Nanjing Insun Feeling Cinema

China / Nanjing
Designer / Ajax Law, Virginia Lung
Company / One Plus Partnership Limited
Photographer / Jonathan Leijonhufvud

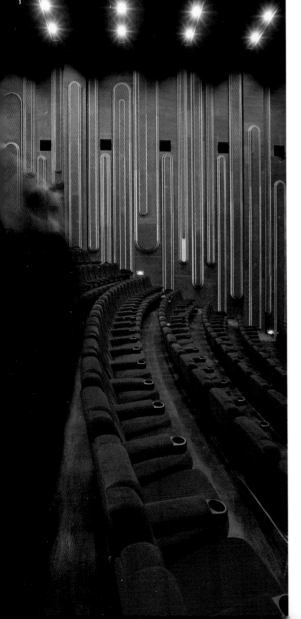

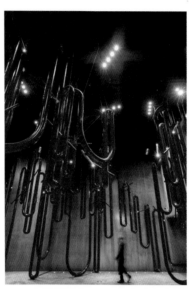

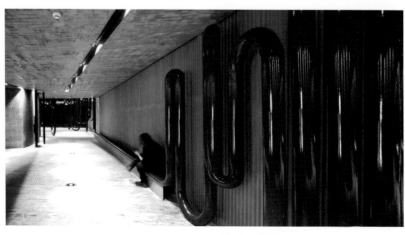

東海侘寂之境

台灣／台中市
設計者／張育睿、陳天助
設計公司／合風蒼飛設計工作室
　　　　　陳天助建築師事務所
作品攝影者／嘿！起司、游宏祥

Old House in Wabi-Sabi

Taiwan / Taichung City
Designer / Yu-Jui Chang, Tien-Chu Chen
Company / Soar Design Studio /
Chen Tien Chu Architects
Photographer / Hey!Cheese, Kyle Yu

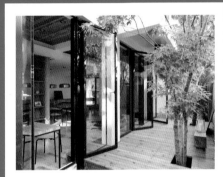

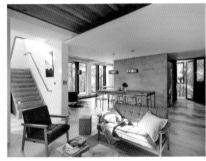

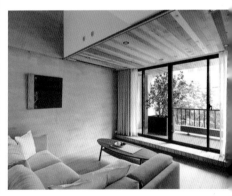

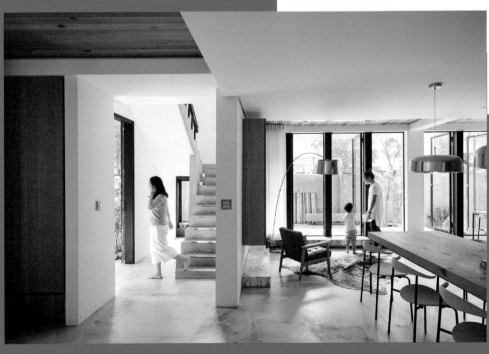

記憶的顯影

設計者／陳連武

設計公司／城市室內裝修設計有限公司

作品攝影者／賴壽山

Manifestation of Memories

Designer / Lien-Wu Chen

Company / Chains interior

Photographer / Lai Shou-shan

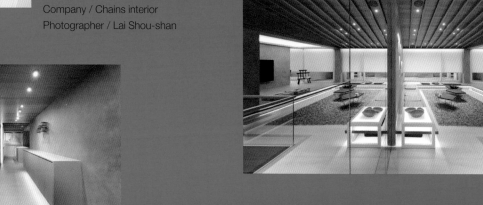

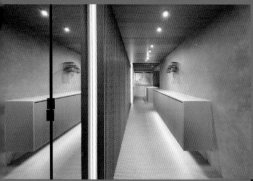

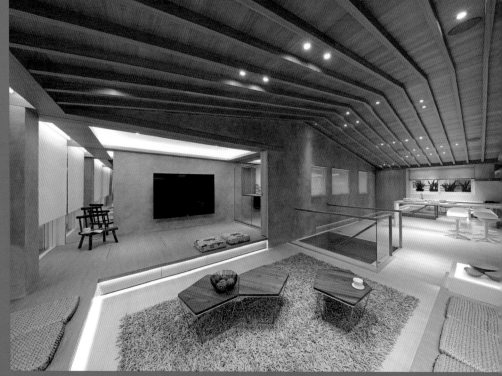

THE TID AWARD OF **RESIDENTIAL SPACE**
MULTI LEVEL

陽明山鄭宅修建住宅

台灣／台北市
業主／鄭宗杰
設計者／何以立、侯貞夙
設計公司／何侯設計有限公司
作品攝影者／C. K. Liao

Cheng Residence, Yangmingshan

Taiwan / Taipei City
Client / Wayne Cheng
Designer / Albert Ho, Jen-Suh Hou
Company / Ho + Hou Studio Architects
Photographer / C. K. Liao

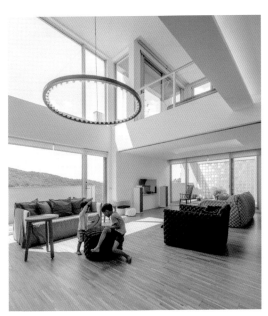
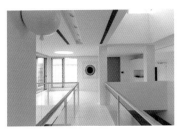
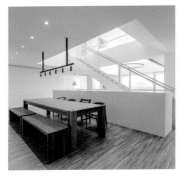
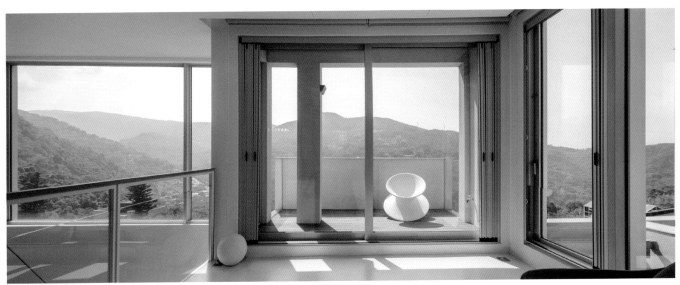

居住空間類/複層 TID獎 漫遊・靈光

THE TID AWARD OF **RESIDENTIAL SPACE**
MULTI LEVEL

漫遊・靈光

台灣／台北市
業主／賴先生
設計者／張向榮、董紀威、許瓊文
設計公司／禾禧設計解決方案
作品攝影者／岑修賢

Flâneur Aura

Taiwan / Taipei City
Client / Mr. Lai
Designer / Jacky Chang, Jerry C. Dung, Wen Hsu
Company / HHC Design Solution
Photographer / Sam

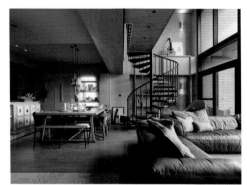

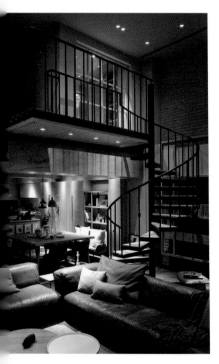

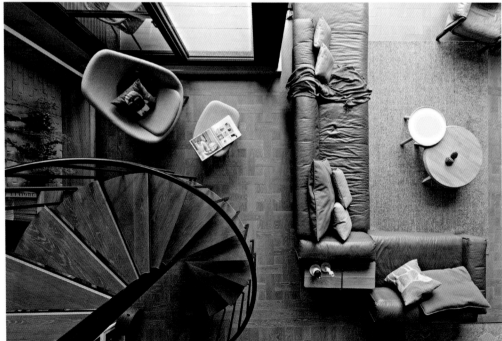

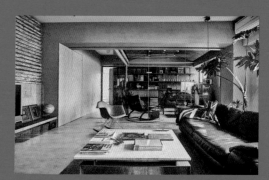

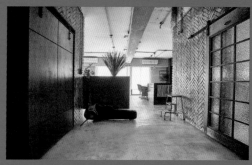

翱翔

台灣／台北市
業主／劉天仁
設計者／陳致豪、曾敏郎、許富順
　　　　顏逸旻、謝佩倚
　　　　郭中元 、廖浩哲
設計公司／三倆三設計事務所
作品攝影者／楊俊嶢

Soaring High

Taiwan / Taipei City
Client / Mr. Liu
Designer / Gary Chen, Bryan Tzeng,
　　　　Hank Hsu, Yi-Min Yen,
　　　　Pei-Yi Sie, Chung-Yuan Kuo,
　　　　Hao-Jhe Liao
Company / 323 interior Ltd.
Photographer / Chun-Yao Yang

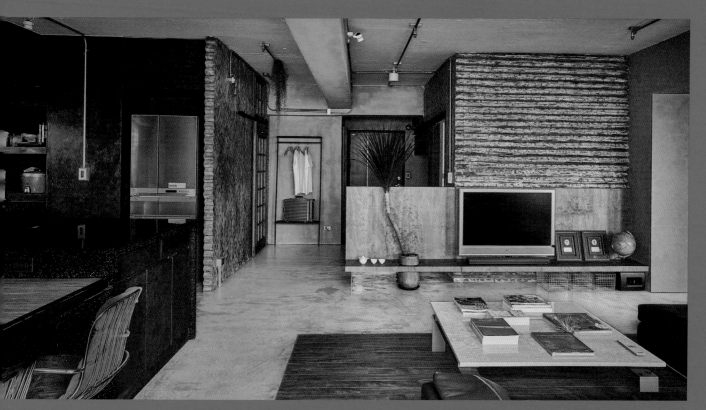

Phoebe Says Wow!

台灣／台北市
設計者／溫茹棻、洪世驊
設計公司／PSW建築設計研究室
作品攝影者／游宏祥攝影工作室
　　　　　黃鈺崴

Phoebe Says Wow!

Taiwan / Taipei City
Designer / Phoebe Wen, Shihhwa Hung
Company / PhoebeSayswow Architects Ltd.
Photographer / KyleYu Photo Studio
　　　　　　Devin Huang

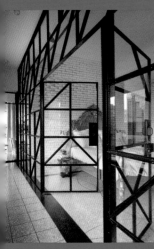
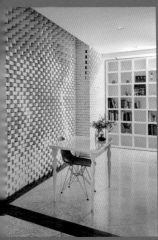
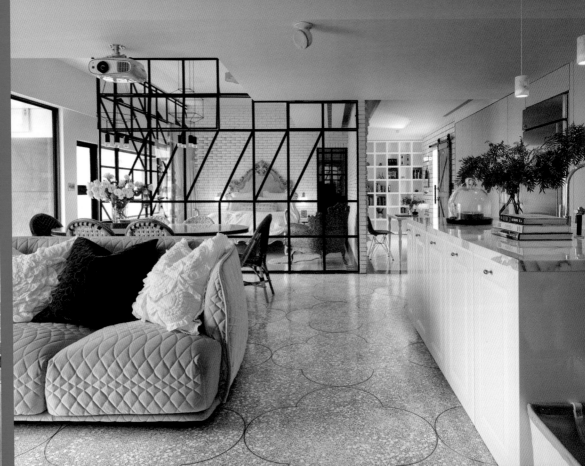

居住空間類/單層 TID獎 境未來

THE TID AWARD OF **RESIDENTIAL SPACE**

SINGLE LEVEL

境未來

台灣／新北市
業主／蔡文哲
設計者／洪博東、吳苡瑄（協同設計）
設計公司／非關空間設計有限公司
作品攝影者／洪博東

Future Space

Taiwan / New Taipei City
Client / Arthur Tsai
Designer / Roy Hong, Hsuan Wu
Company / RoyHong Design Studio
Photographer / Roy Hong

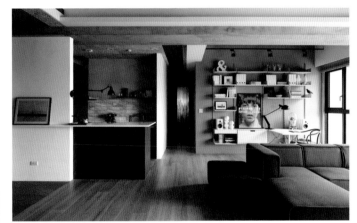

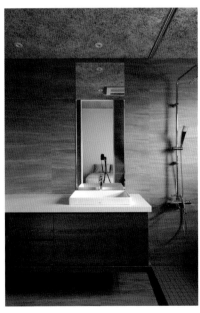

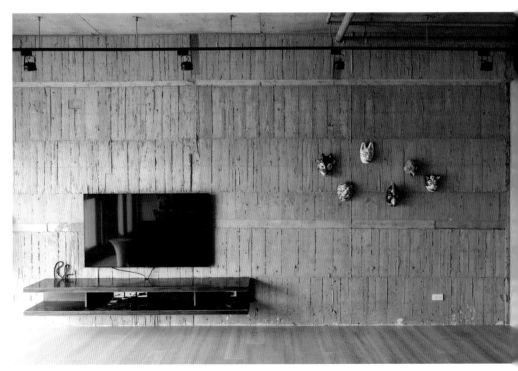

居住空間類/單層 TID獎 內外之間

THE TID AWARD OF **RESIDENTIAL SPACE**

SINGLE LEVEL

內外之間

台灣／台北市
業主／林小姐
設計者／鄭明輝
設計公司／蟲點子創意設計
作品攝影者／嘿!起司

Between Inside and Outside

Taiwan / Taipei City
Client / Ms. Lin
Designer / armin
Company / INDOT Design
Photographer / Hey!Cheese

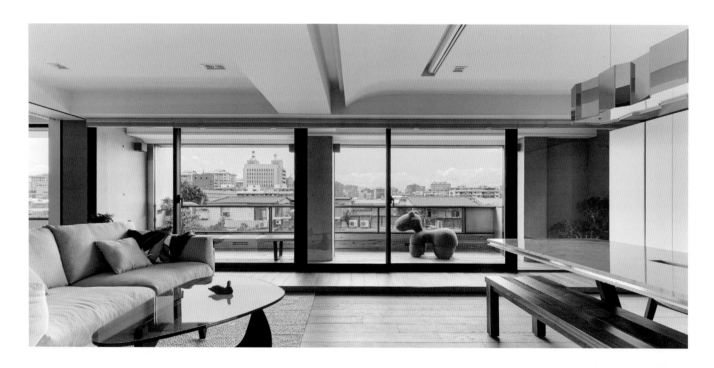

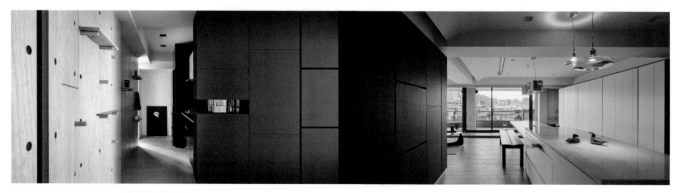

THE TID AWARD OF **RESIDENTIAL SPACE**

SINGLE LEVEL

青舍

台灣／高雄
業主／黃先生
設計者／陳鴻文
設計公司／好室設計
作品攝影者／Hey!Cheese

Blue and Glue

Taiwan / Kaohsiung
Client / Mr. Huang
Designer / Ivan Chen
Company / HAO Design
Photographer / Hey!Cheese

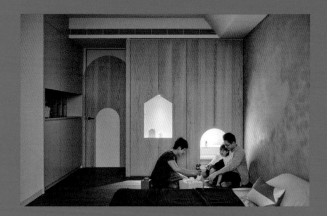

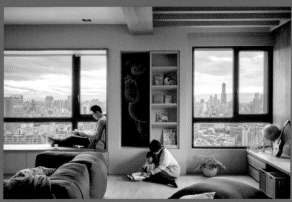

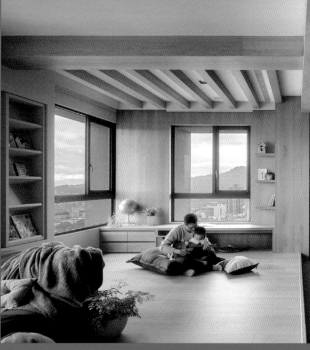

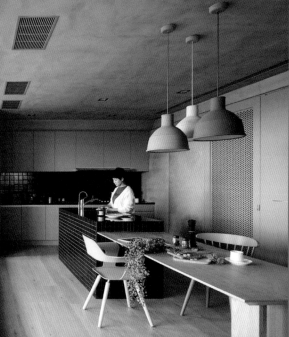

周宅
台灣
業主／周氏夫婦
設計者／周正峰
設計公司／周正峰設計工作室
作品攝影者／游宏祥攝影工作室

KT Apartment

Taiwan
Client / Mr. and Mrs. Chou
Designer / Marty Chou
Company / Marty Chou Architecture
Photographer / Kyle Yu Photo Studio

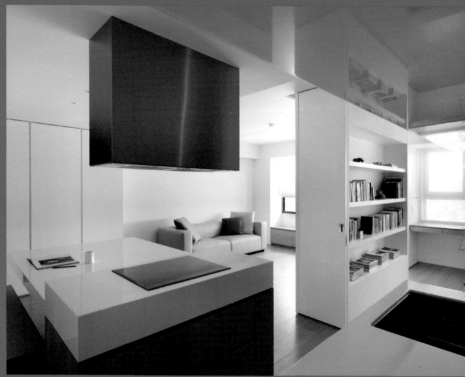

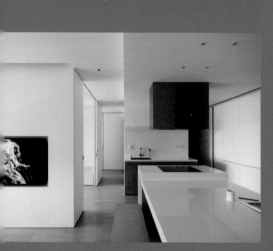

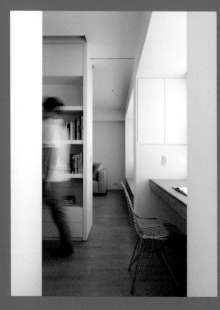

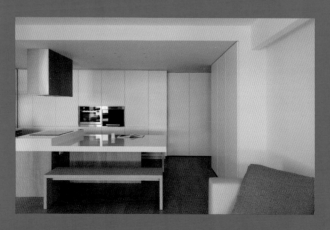

藝術19街

台灣／台中
業主／林裕敏
設計者／黃重蔚
設計公司／新澄設計
作品攝影者／墨田工作室、嘿!起司

Lane 19 Art St.

Taiwan / Taichung
Client / Angle Lin
Designer / Johnson
Company / Newrxid Interior Design
Photographer / Moooten Studio
　　　　　　　 Hey!Cheese

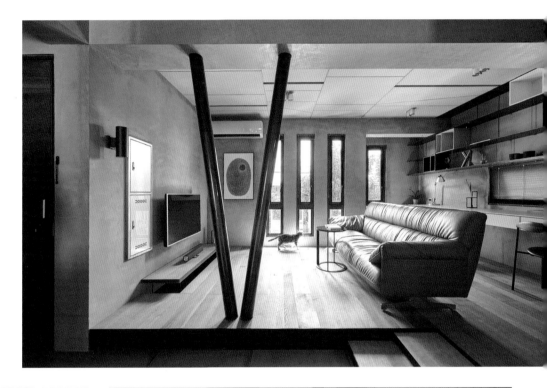

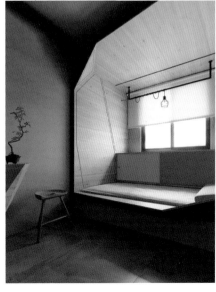

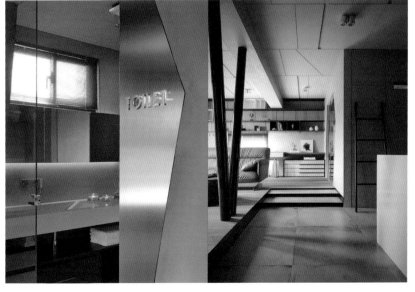

THE TID AWARD OF **RESIDENTIAL SPACE**

SMALL HOUSE

Project No. 314

台灣／台北市
業主／馬幼菁
設計者／黃鈴芳
設計公司／馥閣設計整合有限公司
作品攝影者／吳啟名

Project No. 314

Taiwan / Taipei City
Client / Yu-Ching Ma
Designer / Ling-Fang Huang
Company / Fuge Design Integration Co., Ltd.
Photographer / Kevin Wu

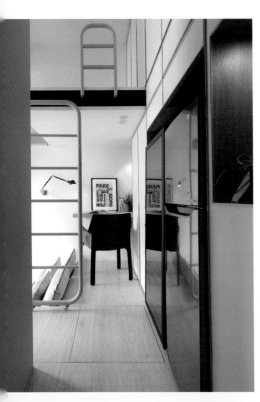

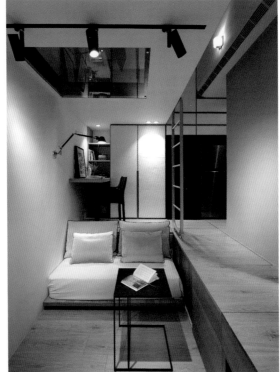

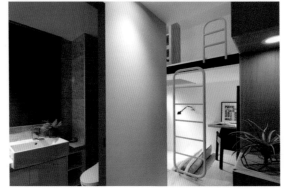

軸轉之間
台灣／台北市
業主／陳美蒨
設計者／邱凱貞、黃振源
設計公司／禾睿設計
作品攝影者／嘿!起司

XY Pivot
Taiwan / Taipei City
Client / Miya Chen
Designer / Gina Chiu, Circle Huang
Company / LCGA DESIGN
Photographer / Hey!Cheese

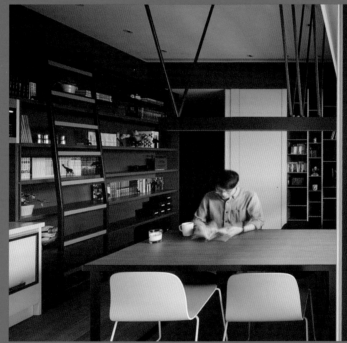
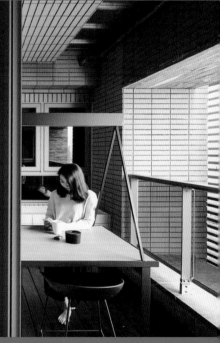

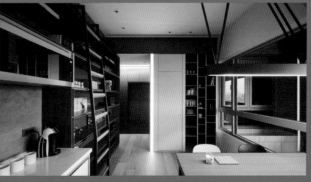

傳承載體・場域串構

中國／北京
業主／北京國際釀酒大師藝術館
設計者／邵唯晏
設計公司／竹工凡木設計研究室
作品攝影者／莊博欽

Transmission-Field Tandem

China / Beijing
Client / MIBA
Designer / Alfie Shao
Company / CHU-studio
Photographer / Ivan Chuang

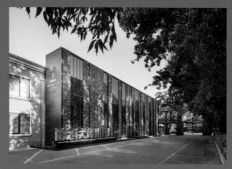

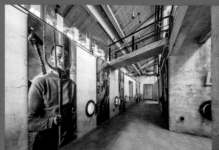

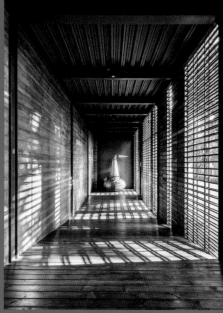

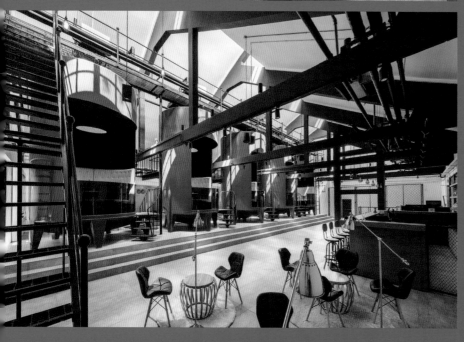

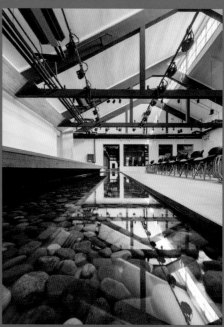

展覽空間類 TID獎　周世雄個展 – 等我一億年

THE TID AWARD OF **EXHIBITIONS SPACE**

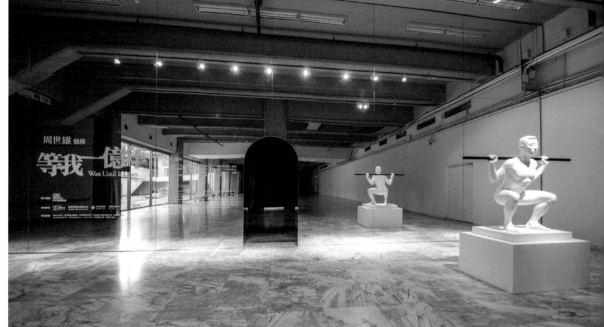

周世雄個展 – 等我一億年

台灣／台北市
設計者／周世雄
設計公司／周世雄工作室
作品攝影者／劉光智

Chou Shih Hsiung Solo Exhibition –
Wait Until It Dries

Taiwan / Taipei City
Designer / Shih Hsiung Chou
Company / Chou Shih Hsiung Art Studio
Photographer / KC Liu

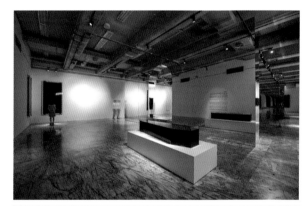

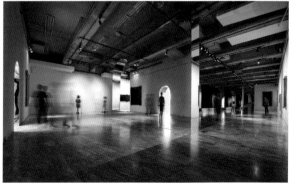

途兒咖啡_城市單車綠洲實驗

台灣／台中市
業主／途兒咖啡
設計者／陳柏齊
設計公司／唐源設計室內裝修企業有限公司
作品攝影者／鳴門視覺文化有限公司 林鉦凱

Toward Café –
Oasis Experiment of Urban Cycling

Taiwan / Taichung City
Client / Toward Café
Designer / Po-Chi Chen
Company / TANG-YUAN Interior Design
　　　　　　Enterprise Co.,Ltd.
Photographer / Cheng-Kai Lin

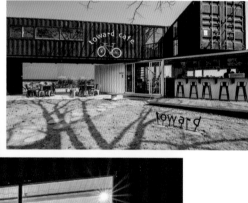

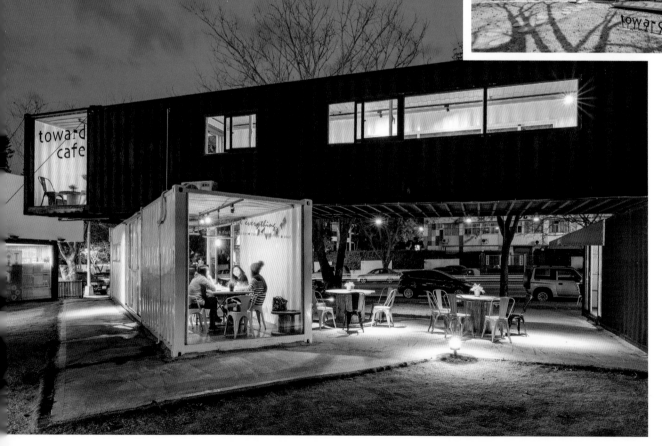

臨時建築與裝置類 TID獎　XYZ嬉遊中-城市搖擺

THE TID AWARD OF **INTERIM ARCHITECT-URE & INSTALLATION**

XYZ嬉遊中-城市搖擺

台灣／台北市
業主／臺北文創基金會
設計者／樂美成、徐士閎
　　　　羅開、鄭又維
設計公司／乡苗空間實驗

XYZ Play-ing: City Swing

Taiwan / Taipei City
Client / Taipei New Horizon Foundation
Designer / Mei-Chen Yueh, Shih-Min Hsu
　　　　　Kai Lo, Yu-Wei Cheng
Company / seed spacelab co.

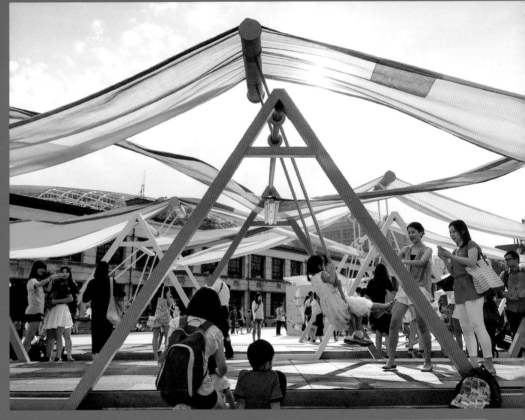

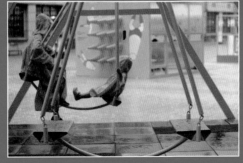

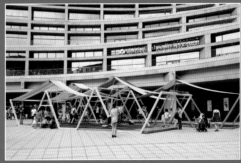

海葵椅

設計者／李怡萱
設計公司／威瑪設計有限公司
作品攝影者／陳志亮

ANEMONE

Designer / Liz Lee
Company / 威瑪設計有限公司
Photographer / Zhi-Liang Chen

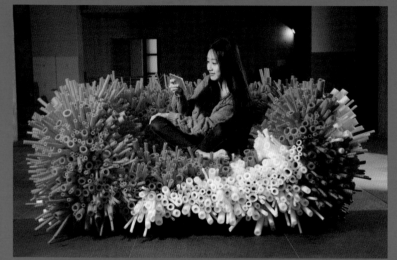

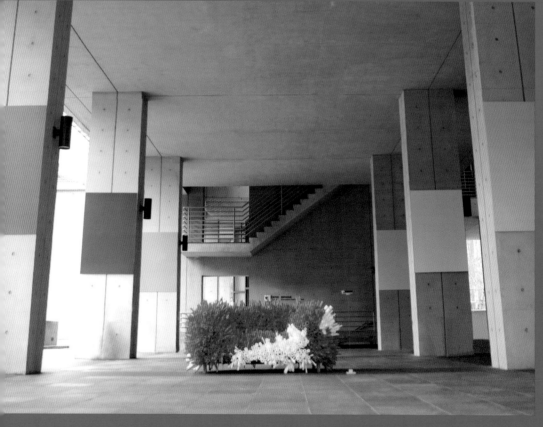

空間裝飾藝術類 TID獎　老屋猶新。毛房蔥柚鍋

THE TID AWARD OF **ART & DECORATION**

老屋猶新。毛房蔥柚鍋

台灣／台南市
業主／豐舟國際股份有限公司
設計者／黃家祥、陳宣維
設計公司／木介空間設計有限公司
作品攝影者／無著色空間影像

The rebirth of an old house-Mao Fun

Taiwan / Tainan City
Client / RICH BOAT International Co., Ltd
Designer / Chia-Hsiang Huang, Hsuan-Wei Chen
Company / MUJIE Design Co.,Ltd
Photographer / Uncoloredspace

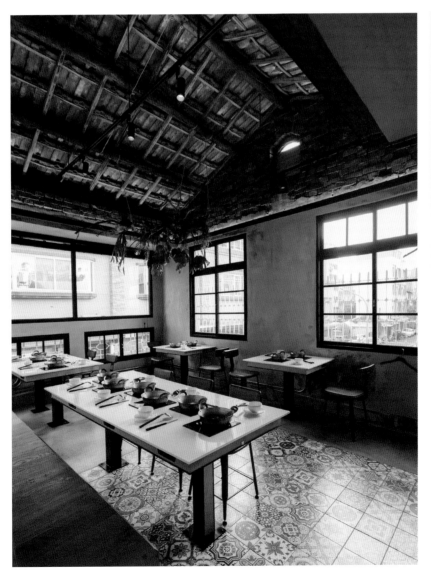

品牌設計類 TID獎　老屋猶新。毛房蔥柚鍋

THE TID AWARD OF BRANDING & COMMUNICATION

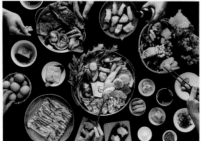

老屋猶新。毛房蔥柚鍋

台灣／台南市
業主／豐舟國際股份有限公司
設計者／黃家祥、陳宣維
設計公司／木介空間設計有限公司
作品攝影者／無著色空間影像

The rebirth of an old house-Mao Fun

Taiwan / Tainan City
Client / RICH BOAT International Co., Ltd
Designer / Chla-Hsiang Huang, Hsuan-Wei Chen
Company / MUJIE Design Co.,Ltd
Photographer / Uncoloredspace

SELECTED

入 圍

公共空間類 入圍　立新國中圖書室

The List of Primary Selected Projects of **PUBLIC SPACE**

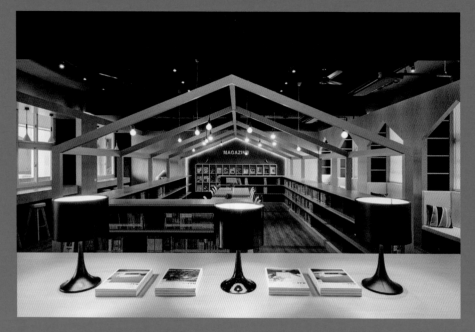

立新國中圖書室

台灣／台中市
業主／立新國中
設計者／蔡顯恭、劉映辰
設計公司／大秝室內裝修設計有限公司
作品攝影者／嘿！起司

Lishin Junior High School library

Taiwan / Taichung City
Client / Lishin Junior High School
Designer / Shian-Gung Tsai, Ying-Chen Liu
Company / TALI design
Photographer / HEY ! CHEESE

公共空間類 入圍　梅溪書院

The List of Primary Selected Projects of **PUBLIC SPACE**

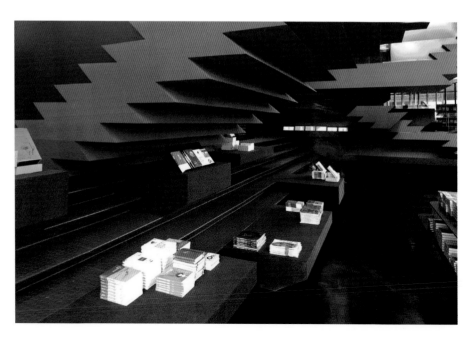

梅溪書院

中國／上海市
設計者／羅靈傑、龍慧祺
設計公司／壹正企劃有限公司
作品攝影者／羅靈傑、龍慧祺

Mezzi Master Bookshop & Exhibition

China / Shanghai
Designer / Ajax Law, Virginia Lung
Company / One Plus Partnership Limited
Photographer / Ajax Law, Virginia Lung

公共空間類 入圍 小玩+

The List of Primary Selected Projects of **PUBLIC SPACE**

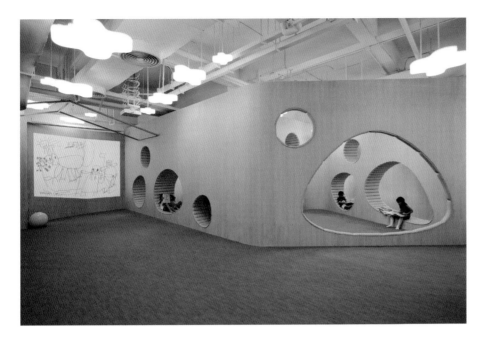

小玩+

中國／深圳
業主／Shenzhen PlayPlus Educational
　　　Company Ltd.
設計者／潘鴻彬、陳凱雯、陳穎芯
設計公司／香港泛納設計事務所
作品攝影者／吳瀟峰

PlayPlus

China / Shenzhen
Client / Shenzhen PlayPlus Educational
　　　Company Ltd.
Designer / Horace Pan, Vivian Chan, Wing Chan
Company / PANORAMA
Photographer / Ng Siu Fung

工作空間類 入圍 乘四研究所

The List of Primary Selected Projects of **WORKING SPACE**

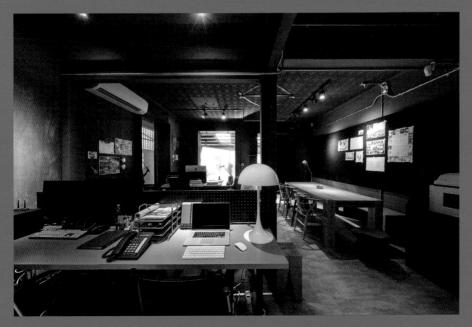

乘四研究所

台灣／台北市
業主／乘四研究所
設計者／程禮志、陳筱婷、林鈺翔
設計公司／乘四研究所
作品攝影者／古之頡

StudioX4

Taiwan / Taipei City
Client / StudioX4
Designer / Lynch Cheng, Ting Chen,
　　　Shane Lin
Company / StudioX4
Photographer / Kelvin Ku

工作空間類 入圍 國泰神坊辦公室

The List of Primary Selected Projects of **WORKING SPACE**

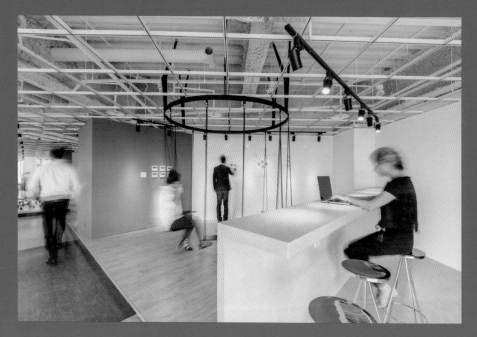

國泰神坊辦公室

台灣／台北市
業主／神坊資訊股份有限公司
設計者／邱柏文
設計公司／柏成設計有限公司
作品攝影者／Zach Hone

Cathay Symphox Office

Taiwan / Taipei City
Client / Cathay Symphox Office
Designer / Johnny Chiu
Company / J.C.Architecture
Photographer / Zach Hone

商業空間類 入圍 美軍俱樂部

The List of Primary Selected Projects of **COMMERCIAL SPACE**
FOOD & BEVERAGE SPACE

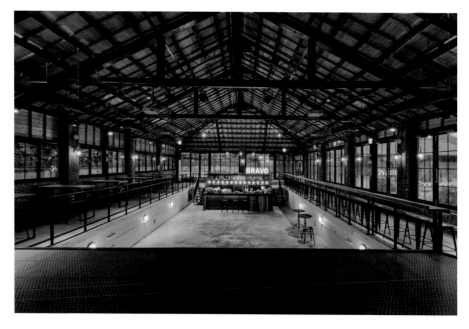

美軍俱樂部

台灣／台北市
設計者／黃建華
設計公司／黃巢設計工務店

Brick Yard 33 1/3

Taiwan / Taipei City
Designer / Chien-Hwa Huang
Company / HC Space Design

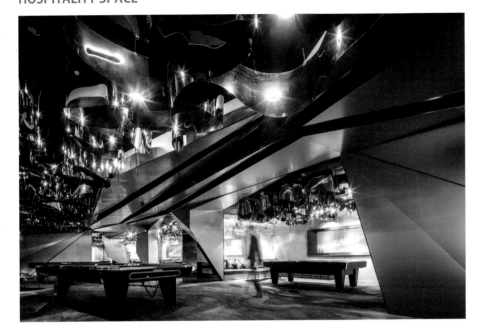

D force

中國／廣州
業主／陳先生
設計者／黃永才
設計公司／共和都市
作品攝影者／李開健、黃永才

D force

China / Guangzhou
Client / Mr. Chen
Designer / Ray Wong
Company / Republic Metropolis Architecture
Photographer / Kaijian Li, Ray wong

商業空間類 入圍 **斯格加旅店**

The List of Primary Selected Projects of COMMERCIAL SPACE
HOSPITALITY SPACE

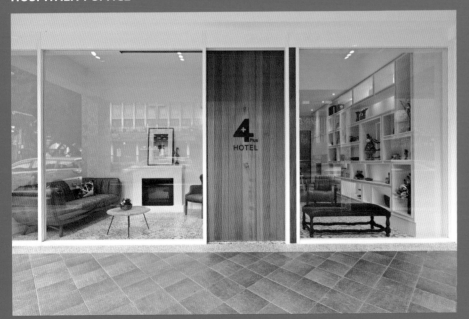

斯格加旅店

台灣／台北市
業主／斯格加旅店
設計者／江俊浩
設計公司／大間空間設計有限公司
作品攝影者／Weimax Studio

4Plus Hoste

Taiwan / Taipei City
Client / 4Plus Hoste
Designer / Chun-Hao Chiang
Company / DAJ Interior Design Co . Ltd
Photographer / Weimax Studio

商業空間類 入圍　杭州百美匯影城

The List of Primary Selected Projects of COMMERCIAL SPACE
HOSPITALITY SPACE

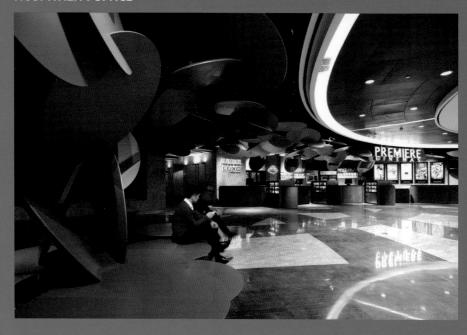

杭州百美匯影城

中國／杭州
設計者／羅靈傑、龍慧祺
設計公司／壹正企劃有限公司
作品攝影者／羅靈傑、龍慧祺

Broadway Palace Premiere Cinema

China / Hangzhou
Designer / Ajax Law, Virginia Lung
Company / One Plus Partnership Limited
Photographer / Ajax Law, Virginia Lung

居住空間類 入圍　Project No. 205

The List of Primary Selected Projects of RESIDENTIAL SPACE
SINGLE LEVEL

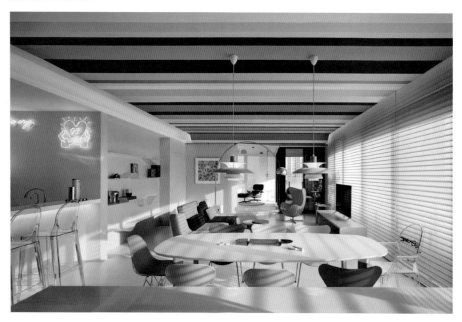

Project No. 205

台灣／竹北市
業主／夏德殷
設計者／黃鈴芳
設計公司／馥閣設計整合有限公司
作品攝影者／藍信沅

Project No. 205

Taiwan / Chupei City
Client / Teyin Hsia
Designer / Ling-Fang Huang
Company / Fuge Design Integration Co., Ltd.
Photographer / Hsin-Yuan Lan

居住空間類 入圍 框·景

The List of Primary Selected Projects of **RESIDENTIAL SPACE**
SINGLE LEVEL

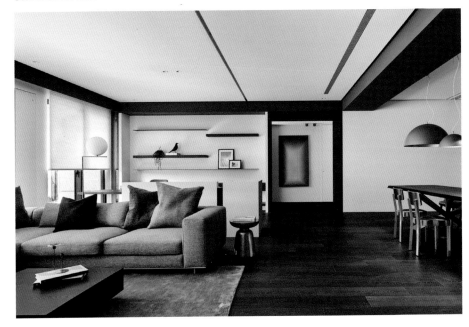

框·景

台灣／林口
業主／劉宅
設計者／洪韡華、留郁琪、曾致豪
設計公司／CONCEPT 北歐建築
作品攝影者／嘿！起司

Enframed Scenery

Taiwan / Linkou
Client / Liu Family
Designer / Wei-Hua Hung, Yu-Chi Liu,
Chih-Hao Tseng
Company / DNA CONCEPT Interior Design
Photographer / Hey! Cheese Photography

居住空間類 入圍 灰之煥

The List of Primary Selected Projects of **RESIDENTIAL SPACE**
SINGLE LEVEL

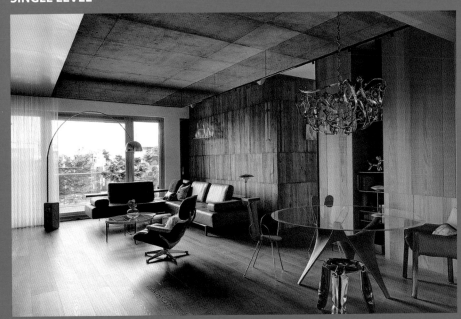

灰之煥

台灣／台北市
業主／Karen Liu
設計者／陳泓宇
設計公司／宇藝空間設計有限公司
作品攝影者／游宏祥

GLIMMER

Taiwan / Taipei City
Client / Karen Liu
Designer / Hung-Yu Chen
Company / Yu ［i］Design Studio
Photographer / Kyle Yu

居住空間類 入圍 釀青

The List of Primary Selected Projects of **RESIDENTIAL SPACE**
SINGLE LEVEL

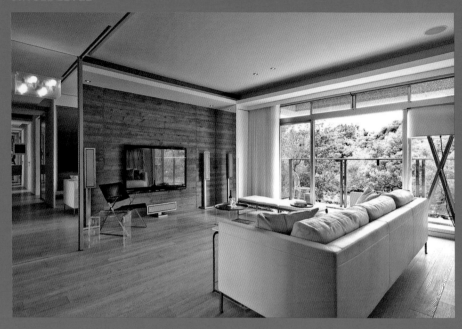

釀青

中國／香港
業主／David Lay
設計者／陳泓宇
設計公司／宇藝空間設計有限公司
作品攝影者／游宏祥

Brewing ……

China / Hong Kong
Client / David Lay
Designer / Hung-Yu Chen
Company / Yu [i] Design Studio
Photographer / Kyle Yu

居住空間類 入圍 迴留

The List of Primary Selected Projects of **RESIDENTIAL SPACE**
SINGLE LEVEL

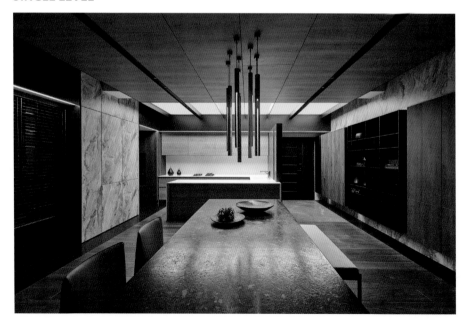

迴留

台灣／新北市
業主／王先生
設計者／王正行、張豐祥、袁丕宇
設計公司／工一設計有限公司
作品攝影者／嘿！起司

FLOW

Taiwan / New Taipei City
Client / Mr. Wang
Designer / Cheng-Shing Wang,
Feng-Hsiang Chang, Pi-Yu Yuan
Company / One Work Design
Photographer / Hey! Cheese

居住空間類 入圍 貓耳洞

The List of Primary Selected Projects of RESIDENTIAL SPACE
SINGLE LEVEL

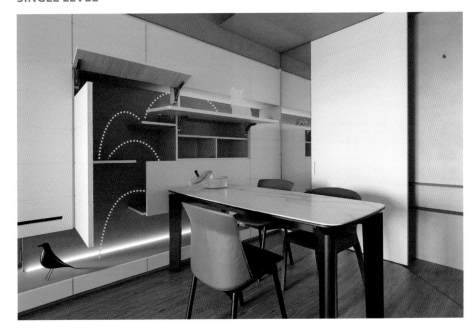

貓耳洞

台灣／新北市
業主／魯先生
設計者／張豐祥、王正行、袁丕宇
設計公司／工一設計有限公司
作品攝影者／岑修賢

Cats' Ear-Shape Cave

Taiwan / New Taipei City
Client / Mr. Lu
Designer / Feng-Hsiang Chang,
Cheng-Shing Wang, Pi-Yu Yuan
Company / One Work Design
Photographer / Sam

居住空間類 入圍 小徑

The List of Primary Selected Projects of RESIDENTIAL SPACE
SINGLE LEVEL

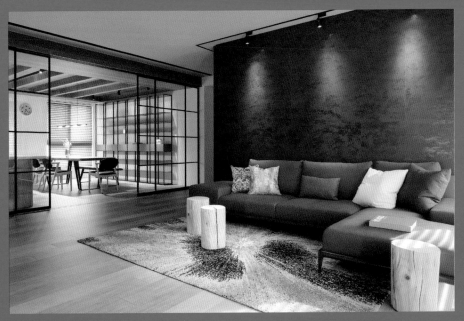

小徑

台灣／桃園市
業主／陳先生
設計者／翁梓富
設計公司／兩冊空間設計
作品攝影者／墨田工作室

Pathway

Taiwan / Taoyuan City
Client / Mr. Chen
Designer / Jeff Weng
Company / 2Books Design
Photographer / Moooten Studio

居住空間類 入圍 高腳屋

The List of Primary Selected Projects of RESIDENTIAL SPACE
SINGLE LEVEL

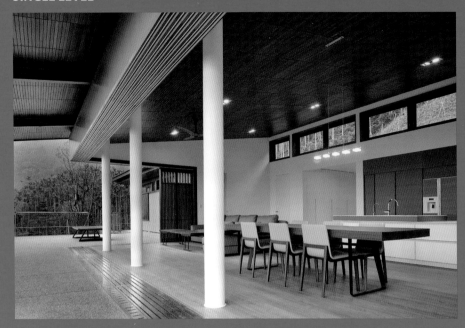

高腳屋

台灣／雲林
設計者／王曉奎
設計公司／王曉奎建築師事務所
作品攝影者／鄭錦銘

Stilted House

Taiwan / Yunlin
Designer / Wang Hsiao-Kuei
Company / Wang Hsiao-Kuei Architecture Studio
Photographer / Chin-Ming Cheng

居住空間類 入圍 旦

The List of Primary Selected Projects of RESIDENTIAL SPACE
SINGLE LEVEL

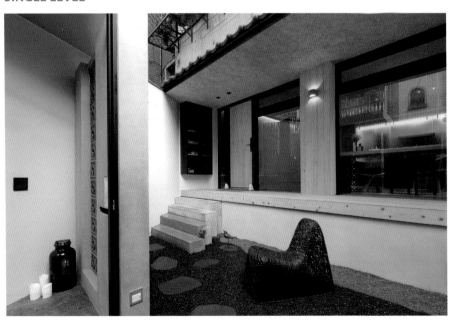

旦

台灣／台北市
設計者／黃祥葆、李慧娟
設計公司／物杰設計有限公司
作品攝影者／Kevin

Dawn

Taiwan / Taipei City
Designer / Hsiang-Pao Huang, Hui-Chuan Lee
Company / 1001 GIVING LIVING
Photographer / Kevin

居住空間類 入圍 No.2 Modern Composition

The List of Primary Selected Projects of RESIDENTIAL SPACE
SINGLE LEVEL

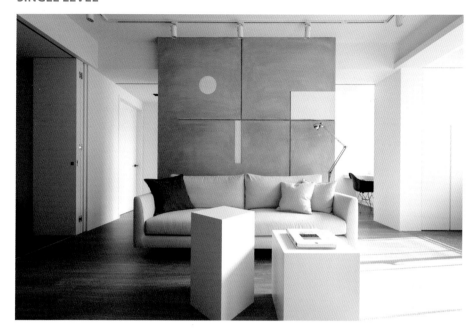

No.2 Modern Composition

台灣／新北市
業主／高宅
設計者／俞文浩、孫偉旻
設計公司／深活生活設計有限公司
作品攝影者／劉士誠

No.2 Modern Composition

Taiwan / New Taipei City
Client / Kao Residence
Designer / Howard Yu, William Sun
Company / Studio In2
Photographer / Jackal Liu

居住空間類 入圍 景與井

The List of Primary Selected Projects of RESIDENTIAL SPACE
SINGLE LEVEL

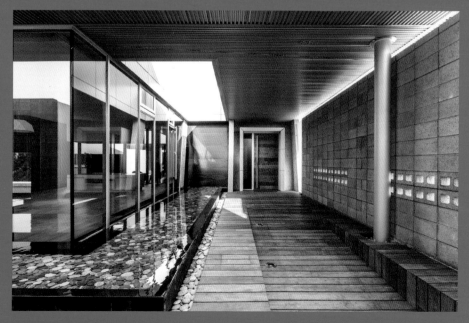

景與井

台灣／彰化
業主／陳怡秀
設計者／魏子鈞
設計公司／兜空間設計＋黃志瑞建築師事務所
作品攝影者／魏子鈞

Courtyard House

Taiwan / Changhua
Client / Mrs. Chen
Designer / Tze-Chun Wei
Company / dotze innovations studio +
 ARJR Architects
Photographer / Tze-Chun Wei

SPONSORS

贊 助

Janet：「認識Caesar這麼多年

凱撒衛浴 好 宅

凱撒衛浴代言人

Janet ♡,

120cm大平直美
Caesar Flora 面盆浴櫃組

敬邀分享 衛浴空間新思維 · 新靈感

瓷藝光廊 凱撒衛浴新形象

陶瓷匠心，大器精細，點亮瓷藝光采魅力

內湖瓷藝光廊
台北市內湖區民善街85號

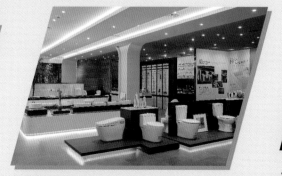
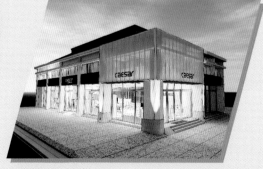

Amazonite MAXIMUM
300x150

新睦豐
BE NEW FORM

世界美學材料圖書館
International Art Materials Gallery

TOTO

與美
自然地共生

回歸陶器的設計原點

綻放素美不矯飾的溫潤線條

絕美的 NEOREST NX

實現自然與美學的和諧共生

NEOREST NX

商品圖僅供參考，商品外觀或規格因應台灣使用環境可能略有不同，歡迎至各經銷點參觀實品

Panasonic
Homes & Living

來自義大利的百年龍頭品牌

PALAZZANI

色彩隨你搭配　生活更家耀眼

好的磁磚　用聽的就知道

冠軍品質　當然不同凡響

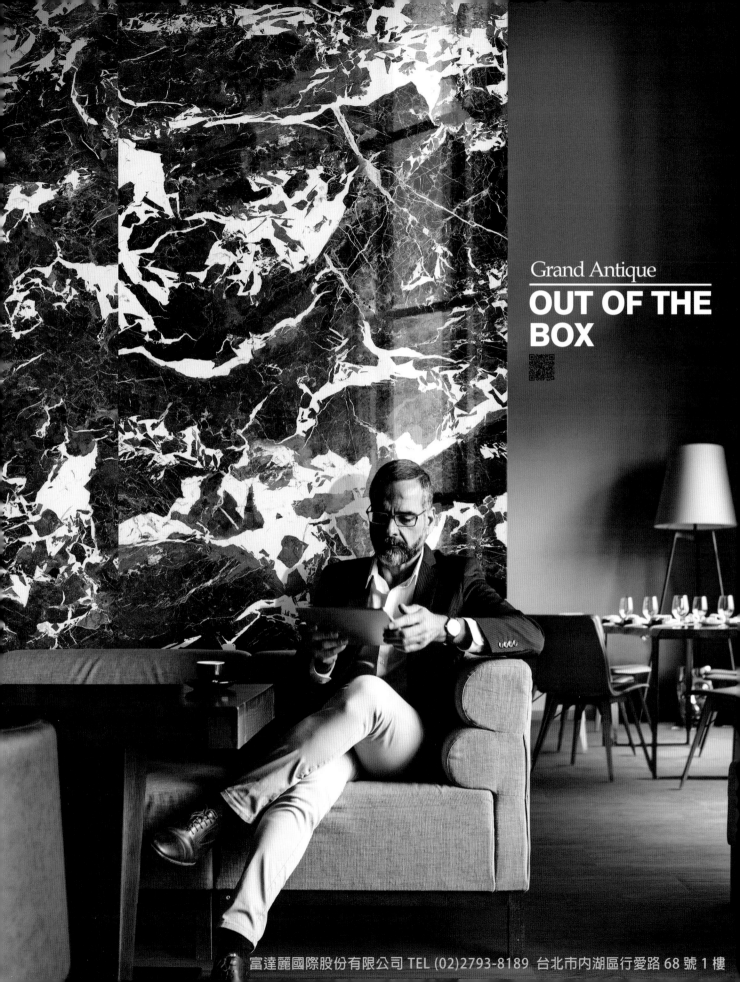

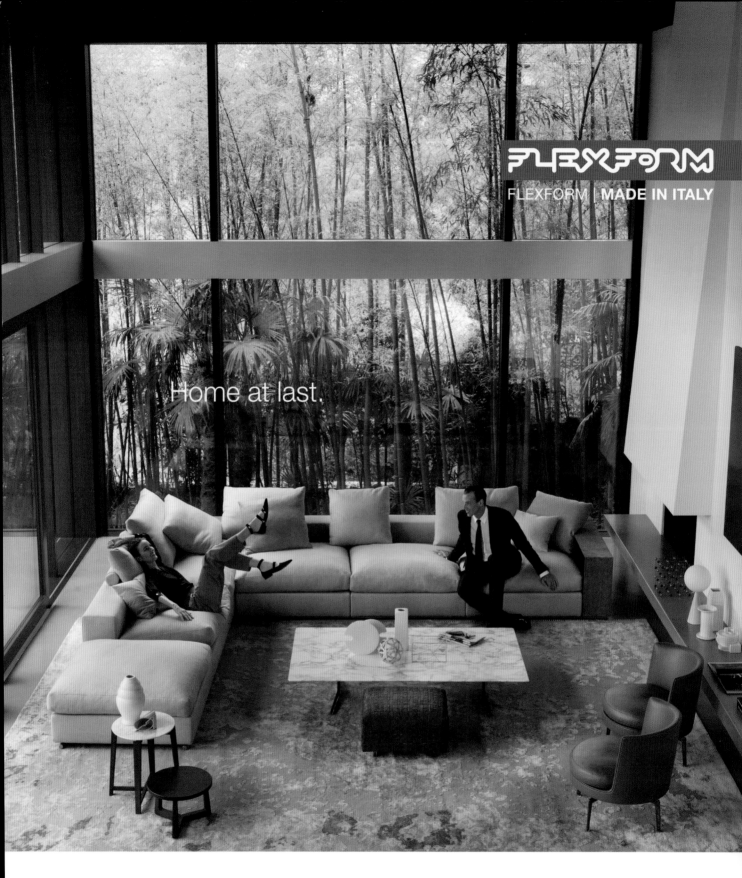

Home at last.

FLEXFORM
FLEXFORM | MADE IN ITALY

INDEX

OF THE 10TH TID AWARD 索引

P038
深宇建築師事務所　Architect Uncharted
Tel：+886-3-4981976
桃園市觀音區福建路一段389巷80號
No.80, Ln. 389, Sec. 1, Fujian Rd., Guanyin Dist., Taoyuan City, Taiwan
www.facebook.com/ArchitectsUncharted

P040
第二計劃　Plan b
Tel：+886-2-25916510
台北市中山區玉門街一號, CIT J室
Rm. J, CIT, No.1, Yumen St., Zhongshan Dist., Taipei City, Taiwan
www.parkup.tw

P044
元崇設計工程股份有限公司　Mandartech Interiors Inc
Tel：+886-2-2346-5633 #216
台北市松德路171號18樓之5
18F-5, 171, Song Der Rd., Taipei, Taiwan
www.mandartech.com

P045
宇寬設計事業有限公司　Koan Design
Tel：+886-2-27651383
台北市民生東路五段220-1號1F
1F., No. 220-1, Sec. 5, Minsheng East Road. Taipei Taiwan
www.koan.com.tw/interior

P046
上勝聯合建築師事務所　Emerge Architects & Associates
Tel：+886-2-23053750
台北市中正區三元街238號5樓
5F., No.238, Sanyuan St., Zhongzheng Dist., Taipei City, Taiwan
www.emergearchi.com

P047 / 063
合風蒼飛設計工作室　Soar Design Studio
Tel：+886-4-23861663
台中市南屯區五權西路二段504號
No.504, Sec. 2, Wuquan W. Rd., Nantun Dist., Taichung City, Taiwan
soardesign@livemail.tw

P048
近境制作設計有限公司　Design Apartment
Tel：+886-2-27073122
台北市大安區瑞安街214巷3號
No.3, Ln. 214, Rui'an St., Da'an Dist., Taipei City, Taiwan
www.da-interior.com

P049 / 088
柏成設計有限公司　J.C. Architecture
Tel：+886-2-23512998
台北市大安區潮州街144號1F
No.144, Chaozhou St. Da-an Dist., Taipei City, Taiwan
www.johnnyisborn.com

P050
層層生活有限公司　PileUp Life Co Ltd
Tel：+886-2 28948939
台北市北投區承德路七段401巷989弄16-1號
No. 16-1, Aly. 989, Ln. 401, Sec. 7, Chengde Rd., Beitou Dist.,
Taipei City, Taiwan
www.pileuplife.com

P051
源原設計　Peny Hsieh Interiors
Tel：+886-955-333440
台北市四維路160巷26號2樓
2F., No.26, Ln. 160, Siwei Rd., Da'an Dist., Taipei City, Taiwan
www.yydg.tw

INDEX
OF THE 10TH TID AWARD

P065
何侯設計有限公司　Ho + Hou Studio Architects
Tel：+886-2-2796-0665
台北市內湖區新湖三路191號4樓之1
4F-1., No.191, Xinhu 3rd Rd., Neihu Dist., Taipei City, Taiwan
hohou.com

P066
禾禧設計解決方案　HHC Design Solution
Tel：+886-2-2518-3533
台北市中山區龍江路235號10樓之1
10F.-1, No.235, Longjiang Rd., Zhongshan Dist., Taipei, Taiwan
www.hhcid.com/web/tw

P067
三倆三設計事務所　323 interior Ltd.
Tel：+886-2-27665323
台北市信義區忠孝東路4段553巷16弄7號3樓
3F., No.7, Aly. 16, Ln. 553, Sec. 4, Zhongxiao E. Rd., Taipei, Taiwan
www.facebook.com/323interior

P068
PSW建築設計研究室　PhoebeSayswow Architects Ltd.
Tel：+886-2-27009969
台北市大安區安和路一段127巷6號2樓
2F., No.6, Ln. 127, Sec. 1, Anhe Rd., Da'an Dist., Taipei City, Taiwan
www.phoebesayswow.com

P069
非關空間設計有限公司　RoyHong Design Studio
Tel：+886-2-2784-6006
台北市大安區建國南路一段286巷31號1樓
1F., No.31, Ln. 286, Sec. 1, Jianguo S. Rd., Da'an Dist., Taipei City, Taiwan
www.royhong.com

P070
蟲點子創意設計有限公司　INDOT DESIGN
Tel：+886-2-89352755
台北市文山區汀州路四段130號1F
1F., No.130, Sec. 4, Tingzhou Rd., Wenshan Dist., Taipei City, Taiwan
www.indotdesign.com

P071
好室設計　HAO Design
Tel：+886-7-3102117
高雄市左營區民族一路1182號
No.1182, Minzu 1st Rd., Zuoying Dist., Kaohsiung City, Taiwan
www.haodesign.tw

P072
周正峰設計工作室　Marty Chou Architecture
Tel：+886-919-935-635
Email：m.chou@martychou.com
www.martychou.com

P073
新澄設計　Newrxid Interior Design
Tel：+886-4-26527900
台中市龍井區藝術街93號2F
2F., No.93, Yishu St., Longjing Dist., Taichung City, Taiwan
www.newrxid.com

P075
禾睿設計　LCGA DESIGN
Tel：+886-2-2547-3110
台北市松山區民生東路三段110巷14號1樓
1F., No. 14, Ln. 110, Sec. 3, Minsheng E. Rd., Songshan Dist., Taipei, Taiwan
www.lcga.net

P089
大間空間設計有限公司　DAJ Interior Design Co . Ltd
Tel：+886-2-23777711
台北市大安區基隆路二段164號2樓
2F., No.164, Sec. 2, Keelung Rd., Da'an Dist., Taipei City 106, Taiwan
daj-design.com

P091
CONCEPT北歐建築　DNA CONCEPT Interior Design
Tel：+886-2-27066136#38
台北市大安區安和路二段32巷19號
No.19, Ln. 32, Sec. 2, Anhe Rd., Da'an Dist., Taipei City, Taiwan
dna-concept-design.com

P091 / 092
宇藝空間設計有限公司　Yu [i] Design Studio
Tel：+886-2738-8918#102
台北市安和路二段241號11樓
11F., No. 241, Sec. 2, Anhe Rd., Da'an Dist., Taipei City, Taiwan
Yui.design@msa.hinet.net

P094
王曉奎建築師事務所　Wang Hsiao-Kuei Architecture Studio
Tel：+886-6-2996048
台南市安平區慶平路507-2號4F-2
Rm. 2, 4F., No. 507-2, Qingping Rd., Anping Dist., Tainan City, Taiwan
wanghsiaokuei.com

P094
物杰設計有限公司　1001 GIVING LIVING
Tel：+886-986-851-001 ex.10951
台北市中山區仁愛路二段45號4樓
4F.,No.45, Sec. 2, Ren'ai Rd., Zhongzheng Dist., Taipei City, Taiwan
www.1001gl.com

P095
深活生活設計有限公司　Studio In2
Tel：+886--2-2393-0771
台北市忠孝東路二段134巷24-3號3樓
3F, No.24-3, Ln. 134, Sec. 2, Zhongziao E. Rd., Taipei City, Taiwan
www.studioin2.com

P095
兜空間設計 + 黃志瑞建築師事務所
dotze innovations studio + ARJR Architects
Tel：+886-952186206
彰化縣社頭鄉中山路一段666號
No.666, Sec.1, JhongShan Rd.,Shetou, Changhua County, Taiwan
www.studiodotze.com

2017 第十屆台灣室內設計大獎

發行人／龔書章

出版者／中華民國室內設計協會（CSID）

編輯顧問／Peter Zec、王玉麟、安郁茜、朱平、季裕棠、姚政仲、胡碩峯
張光民、陳瑞憲、陸希傑、黃湘娟、楊岸、詹偉雄、簡學義、關傳雍

編輯委員／王玉麟、姚政仲、黃湘娟、簡學義、龔書章

英文編審／Debbie C. Yang

創意總監／趙璽

地址／台北市信義區光復南路133號 松山文創園區133號共創合作社南三

電話／+886 2 2746 0133

美術設計／大於二創意

印刷／懋元彩色印刷有限公司

定價／880元

初版一刷／2020年3月

ISBN 978-986-84055-9-2

TID電子書刊物 免費下載

Editorial Director／Shu-Chang Kung

Publisher／Chinese Society of Interior Designers

Editorial Advisor／Peter Zec, Yul-Lin Wang, Yu-Chien Ann, Pin Chu, Tony Chi, Cheng-Chung Yao, Shyr-Fong Hu, Tony K.M. Chang, Ray Chen, Shi-Chieh Lu, Peggy Huang, Alexander Yang, Wei-Hsiung Chan, Hsueh-Yi Chien, Ernest Guan

Editorial Board／Yul-Lin Wang, Cheng-Chung Yao, Peggy Huang,Hsueh-Yi Chien, Shu-Chang Kung

English Proofread and Revised／Debbie C. Yang

Creative Director／Chao-Hsi

Address／S3 Union No.133,Guangfu S. Rd., Xinyi Dist.,Taipei City 110,Taiwan

Tel／+886 2 2746 0133

Design／2 Big Adv.

Printing／Maoyuan Printing limited Co.

Pricing／NT$ 880

Issuing Date／2020.3